PEOPLE PAINTING
SCRAPBOOK

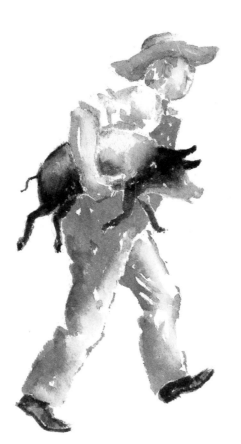

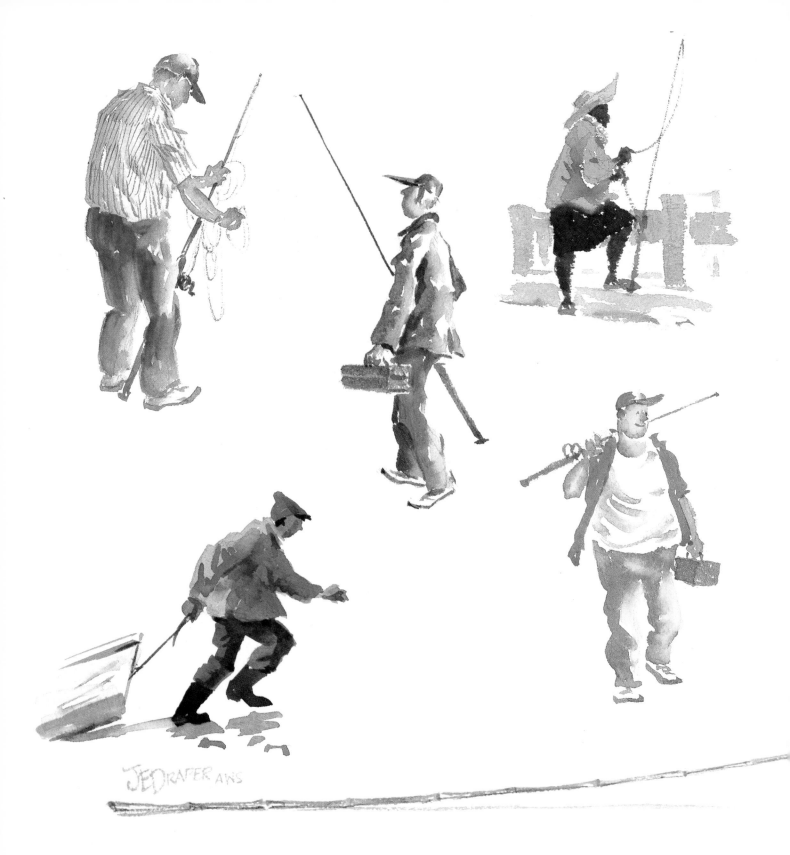

PEOPLE PAINTING
SCRAPBOOK

J. Everett Draper, A.W.S.

Cincinnati, Ohio

My sincere thanks to David Lewis for encouraging me to write this second book, and to Greg Albert who, as my editor, managed to make sense and create a book out of the material I sent him.

Collection of Mr. and Mrs. Robert B. Whyte

People Painting Scrapbook. Published by North Light, an imprint of F&W Publications, 1507 Dana Avenue, Cincinnati, Ohio 45207.

93 92 91 90 89 88 5 4 3 2 1

Library of Congress Cataloging in Publication Data

Draper, J. Everett.
 People painting scrapbook / J. Everett Draper.
 p. cm.

 ISBN 0-89134-252-4 : $24.95
 1. Human figure in art. 2. Painting—Technique.
3. Artists' preparatory studies. I. Title
ND1290.D728 1988
751.4—dc19 88-5359
 CIP

Editor: Greg Albert
Designer: Carole Winters

Dedicated once again with love to Evelyn—
and to my daughter Pam, my son Dick, and grandson Bill.

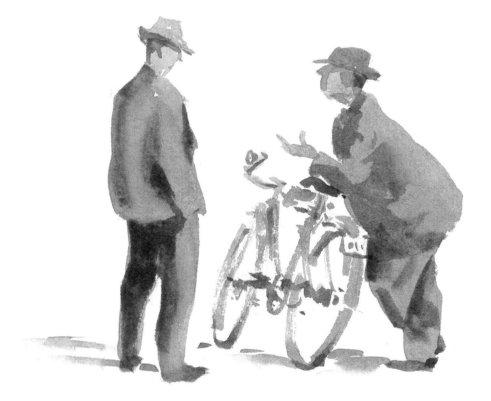

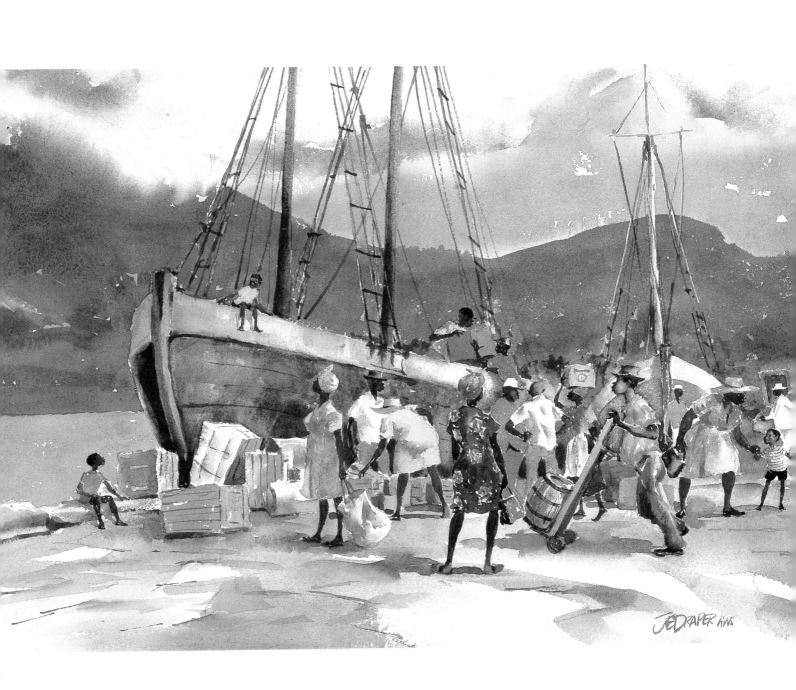

Contents

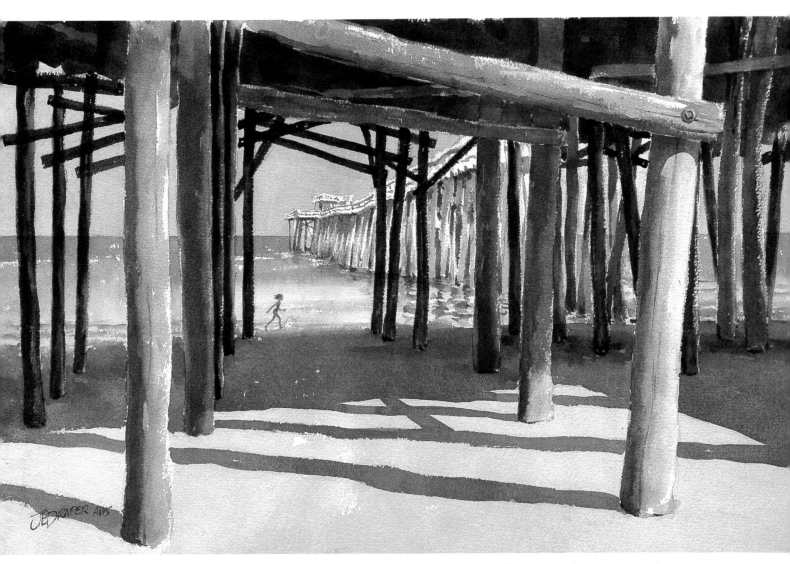

Beach Bunny

This is a scene under the Jacksonville Beach Pier in Florida, not far from my home. Like many cities along the coast, Jacksonville has a fishing pier that charges admission for fishing. The figure is strategically placed here so the focal point and center of interest coincide.

The eye is always attracted to the area of greatest contrast and to the figure in a painting, so it made sense to place the little girl in the "window frame" formed by the pilings supporting the pier.

INTRODUCTION

This is a specialized book dealing with the drawing and painting of small figures that are an incidental part of a painting's composition.

Though almost all of the art in the book is in watercolor, this is not only a watercolor book. The information in this book can be applied to any medium.

This book will not deal with large, detailed figures. Larger figures would require a more studied approach involving details of anatomy, light and shape, and the possible use of models. This book will concentrate on capturing the essence of a small figure's action and identity. Simple figure representation ranges from capturing your subject's gesture with a quick brush stroke to capturing its identity by means of its correctly proportioned silhouette shape.

This book cuts directly to the problem of producing small, simply executed figures designed to be part of a painting without necessarily being the focal point. Being able to properly construct these figures and add them to your paintings enables you to supply your paintings with added interest, including the element of life.

Drawing without a model is a simple fact of life for most landscape painters who just want to add a figure or two to a painting. Either because no people were there when he was painting or sketching, or because they had moved on before he finished, he is faced with the problem of supplying his landscape with figures of his own creation or from memory.

Even though this is a book for painters, it begins with drawing and emphasizes drawing skills throughout. A foundation of good drawing skills is essential to the success of painting, especially drawing the human form. Drawing is a skill that can be developed by constant practice. The most important exercise to develop this skill is the gesture drawing, a small, quickly executed sketch of your subject in action. This is the topic of chapter 2. In chapter 3, I show you how to develop the quick gesture drawing into a final rendering suitable for inclusion in your paintings. To do that, you must be familiar with certain facts about the body, so your developed figure will be properly proportioned and anatomically accurate with a convincing sense of action. Chapter 4 shows you how to make your figure fit into the painting so it looks like it belongs. The figure in groups is discussed in chapter 5. The whole process of sketching, developing a final image, and then putting it into your painting is detailed in five demonstration sequences in chapter 6.

Throughout the book you will find an inventory of a hundred or more small figures located at random in the margins wherever space permits. These, plus many more figures in the various illustrations and paintings, are there for your reference.

I will show you how you can populate your paintings with small but lively figures to add that necessary spark of life to your art. I hope that what you find in this book will be your means of producing good, credible figures that will add interest and reality to your paintings.

Indian River Bridge, Florida
Collection of Indian River Plantation

CHAPTER ONE

Getting Into the Habit

In a book devoted to painting the human form, whether in small, casually handled representations or larger renderings, drawing becomes an all important consideration. The importance of good drawing as a foundation for all art of this kind will be emphasized throughout this book. To a painter interested in using the human form, the importance of a solid foundation in drawing is immediately obvious. I have seen many a painting spoiled by an inept attempt to include a figure that required a certain amount of drawing skill the artist simply didn't have. It seems some painters draw better than others and some can't seem to draw at all. But there is hope. For those who have the self-discipline to take the time and make the effort, drawing is a skill that can be rapidly improved by practice.

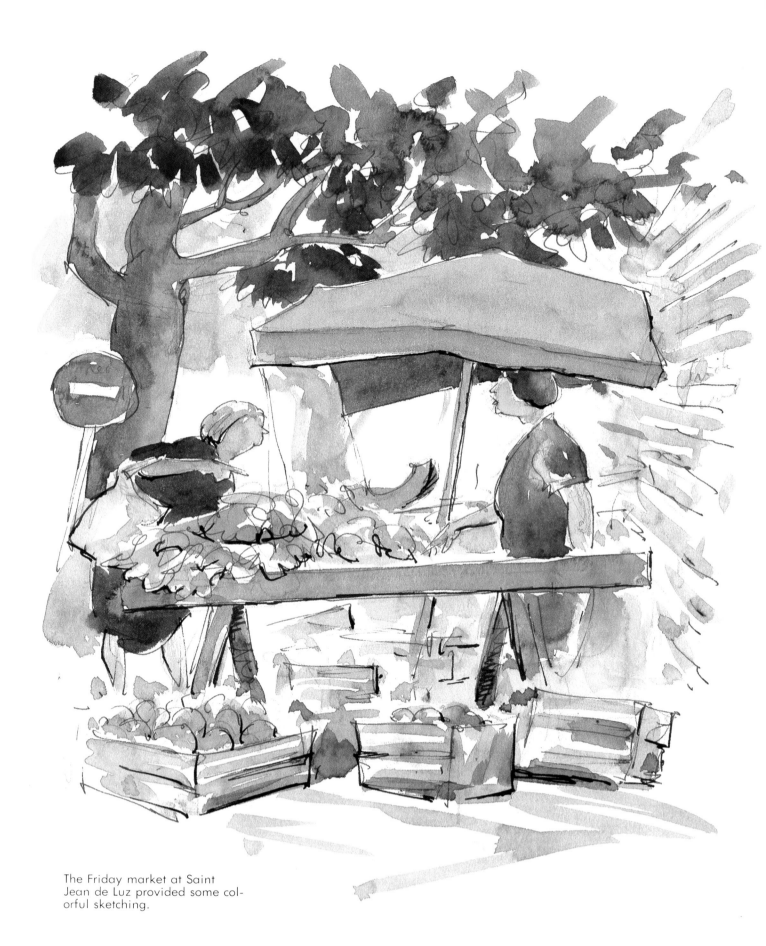

The Friday market at Saint Jean de Luz provided some colorful sketching.

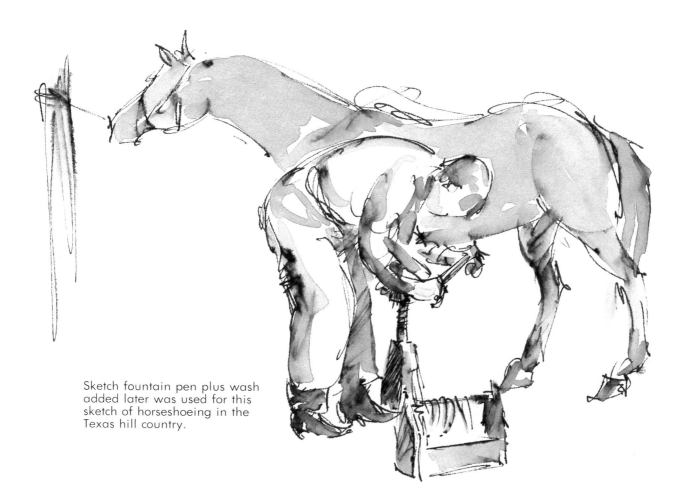

Sketch fountain pen plus wash added later was used for this sketch of horseshoeing in the Texas hill country.

The Habit of Constant Drawing

The habit of constantly drawing is one positive way of developing your drawing skills. Developing this habit means getting to the point where you can't have a pencil in your hand without having the urge to draw or at least doodle. You can cater to this habit by always having a pencil or pen as well as a notebook or sketchbook at hand.

If you want to draw well, it will take constant practice. You'll have to find ways to work it into your daily routine. Usually there are many opportunities during the day to grab a quick sketchbook impression: at a traffic light, in a doctor's waiting room, or riding a bus are just a few examples. It may be only a fragment of a sketch, but that is all you need to nail down an idea. Even if the setting is dull or uninspiring the opportunity for practice is still there.

In fact, in the process of sketching you may find the subject of your sketch is more interesting than you at first imagined. One of the extra dividends of sketching is the increased pleasure and awareness it adds to your life.

Learn to study your surroundings and the people around you from the standpoint of drawing. Even if you don't have your drawing equipment with you, you can still "draw in your head." Think to yourself, "How would I sketch that?" and imagine the drawing in your mind's eye.

Draw every single day, even if it is for only a few minutes at a time. Drawing a few minutes a day will do you more good than an art class once a week. But do the art class too.

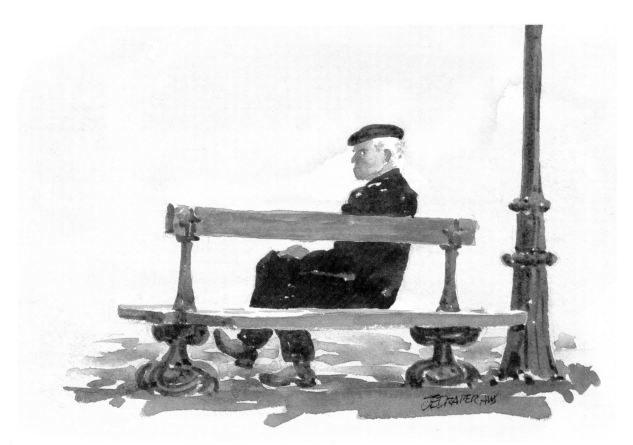

I was trying to be careful. I never want to annoy. This Basque gentleman spotted me sketching and moved away.

The Sketchbook

An essential part of the drawing habit is the habit of carrying a sketchbook. This might be a nuisance at times, but if you want to draw badly enough it is a nuisance you can get used to. Sketchbooks come in a great variety of sizes and shapes. You might be inclined to pick the smallest one you can find, one that can be tucked away in a pocket. The trouble is that if it is out of sight, it is out of mind, and you won't remember to use it when you should. A larger sketchbook creates the problem of having to carry a bulky object in your hand. But if it isn't too large, you can get accustomed to it quickly and you will probably use it more. Soon you will feel uncomfortable without it.

The self-consciousness of sketching in public disappears after a while. When this happens you can graduate to a better size sketch-book, at least 9" × 12" (23 × 31 cm.), which is big enough to rest your drawing hand on so you can do a serious job of sketching.

Many artists become too preoccupied with producing a presentable sketchbook. These artists are hesitant to start a sketch with a tool that makes an absolutely permanent line. They would rather lay a light and tentative sketch using something erasable before committing themselves and their sketchbook to a marker or pen. This is a safe approach that usually results in a neat sketchbook, but a neat sketchbook is not really very important.

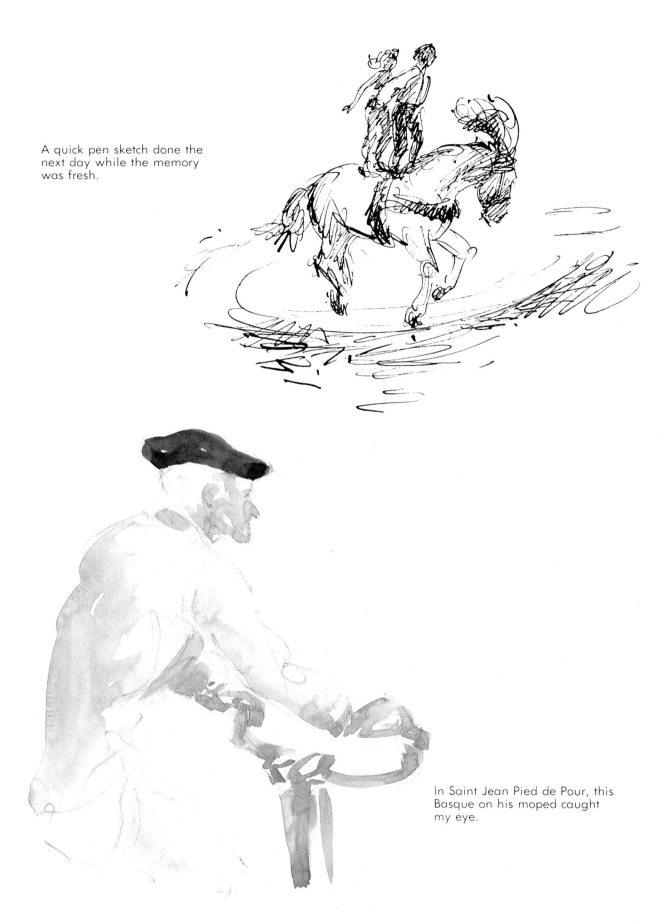

A quick pen sketch done the next day while the memory was fresh.

In Saint Jean Pied de Pour, this Basque on his moped caught my eye.

Food vendors in Bangkok both afloat and ashore, done with a felt tip pen.

Don't hesitate to record important information in your sketchbook. This shipyard welder had an orange sweatshirt.

Drawing Tools

Much more important is developing your ability to make a direct statement with any tool at hand. After all, a sketchbook is a personal thing for your eyes and information only. If a line is wrong, correct it by drawing over or through it. Actually, the mistakes and the working-over may add to your recall by providing additional information when the time comes to use the sketch as a basis for a more developed figure in a painting.

Occasionally it may be desirable to add color or further refinement to a sketch to amplify its usefulness, but I don't believe in carrying extra supplies for this purpose. It is usually better to doctor your sketches later at home or in the studio. Sometimes I'll reinforce a pencil drawing with a more permanent medium such as ink.

The most available and easiest sketching tool is the ordinary lead pencil. It is the favorite of the tentative artist mentioned above and it is no doubt a good and responsive tool. Unfortunately the lead pencil will smear and the drawing will offset on the facing page. A good substitute that doesn't smear is the Prismacolor pencil. This pencil comes in all colors. It doesn't smear but neither does it erase.

The best advice for the artist in search of suitable materials is to experiment. Sketch fountain pens, many Japanese fine line pens, and a greater variety of markers than I can list here are available on the market. Keep trying new tools until you find one that is easy to use and fits your drawing style. Then keep it with you at all times.

A St. Augustine carriage driver waits for a customer.

Where to Draw

Much of the subject matter in this book seems to be related to faraway lands and exotic locations. This may lead to the misconception that to see something interesting enough to sketch or paint, you must go to some quaint or extraordinary place.

To the contrary, subject matter is not what makes a painting successful or unsuccessful. The most mundane subject can be transformed into a powerful composition. Good opportunities for sketching are everywhere around you and as close as your own neighborhood. It just takes your artist's eye to recognize the possibilities.

We are interested mostly in people. The world immediately around you, regardless of where you live, offers people working, playing, and just living their daily lives. Train yourself to observe. Keep your sketchbook at hand and work to develop the sketchbook habit. Keep one handy in your car and carry one with you wherever you go.

Your realization of the potentialities of your sketches will soon overcome any self-consciousness about sketching in public. However, you must hone your skill by making special trips to where people gather and do things.

Sometimes you don't have to
go far to find great sketching
opportunities. The *skateboard*
park turned out to be a great
scene of fast action and young
subjects.
 Concern for accuracy of
equipment and the psychedelic
outfits resulted in slightly tight-
er figures.

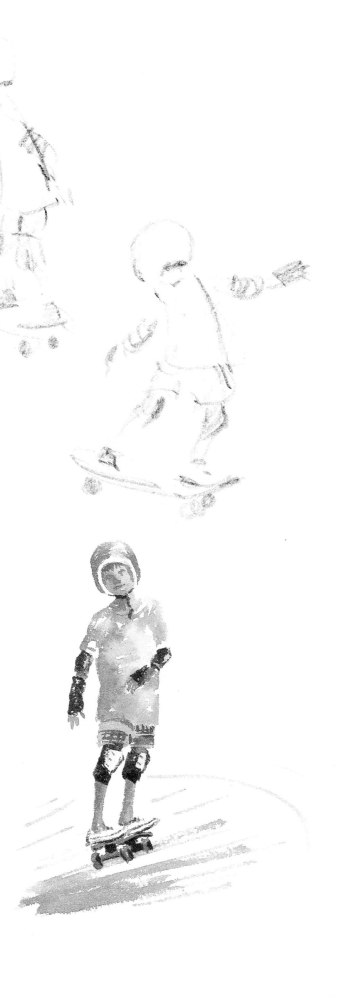

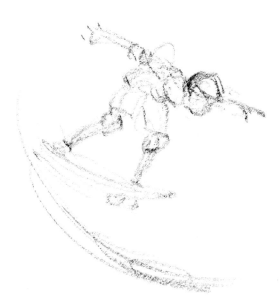

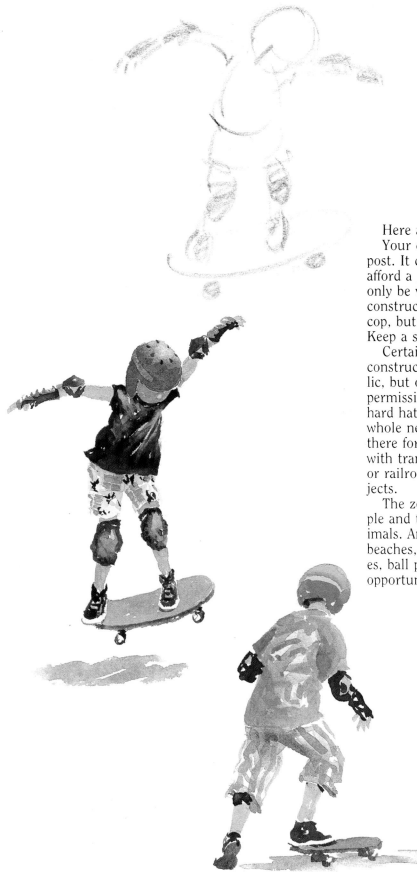

Here are a few tips on where to sketch.

Your car can make an excellent observation post. It can often be parked in a location to afford a good view of some activity. You may only be viewing some pedestrians, a street construction crew, or a hardworking traffic cop, but the sketch possibilities are there. Keep a sketchbook in your car at all times.

Certain workplaces such as shipyards and construction sites might be closed to the public, but often you can gain entrance by asking permission. You might be asked to wear a hard hat and be told where not to go, but a whole new world of subject matter might be there for you. Almost any place connected with transportation, such as terminals, docks, or railroad yards, also abounds with good subjects.

The zoo is a great place to sketch. The people and the kids can be more fun than the animals. Any place where people play, including beaches, ski slopes, amusement parks, circuses, ball parks, and play fields are also good opportunities.

On the road on Antigua.

Places such as a shopping mall offer the possibility of sitting quietly off to the side and observing the flow of shoppers. You might have an occasional audience of one or two, but this is just part of being an artist, and it shouldn't bother you.

Other places where people buy and sell, including farmers' markets, flea markets, and yard sales offer excellent sketching opportunities. Bring a folding stool with you. You can probably get permission to sit in an out-of-the-way spot where you can get a good view of the action. It might pay to buy some small item of junk to help your cause.

"People sketching" opportunities exist wherever there are people, and there are people all around you. There is no need to travel to the four corners of the earth for interesting subject matter, although I will admit it's fun.

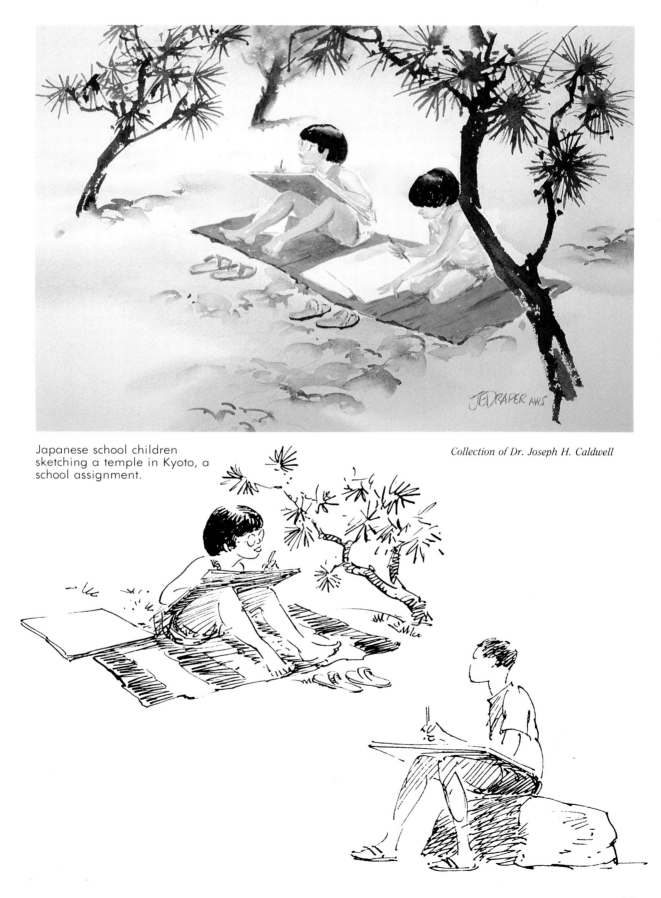

Japanese school children
sketching a temple in Kyoto, a
school assignment.

Collection of Dr. Joseph H. Caldwell

13

Doodles

The drawing habit breeds doodlers. In my opinion, doodles are a manifestation of a lifelong habit of drawing that has taken hold. I think most doodling takes place as people daydream or talk on the phone, although in my case, I remember getting into trouble in school for doodling in my schoolbooks instead of studying. Even today I sometimes lose track of a phone conversation because the absentminded doodle I am creating becomes more interesting.

Some years ago my wife, Evelyn, started collecting some of the doodles that cluttered the telephone desk in our kitchen. The drawings were done on any available scrap of paper, including her grocery lists and other notes. When I started working on this book, she surprised me by bringing them forth. I'm showing you a small portion of them here.

I think the doodles are interesting for several reasons. First, because they were drawn while thinking and talking about other things, I think they display a subconscious knowledge of form and drawing that has been built up by my lifelong habit of drawing. Second, the subject matter is revealing, although I'm not sure exactly what they say about my imagination. Third, they were done with whatever materials happened to be handy.

It's hard to say where my subconscious knowledge of form came from. In my case, I always had a great interest in art generally, plus a special interest in the works of this country's great illustrators. I was fortunate enough to have been exposed to some superb art and illustrations while attending art school and while working later as a commercial artist. The habit of constant observation developed naturally. If my drawings today indicate a knowledge of form, I'm sure this constant practice was the reason.

If you want to improve your drawing skills, cultivate the habit of constantly drawing. There is no way around this practice, but luckily this practice can be rewarding and pleasant. The habit of constantly drawing reaps almost immediate benefits.

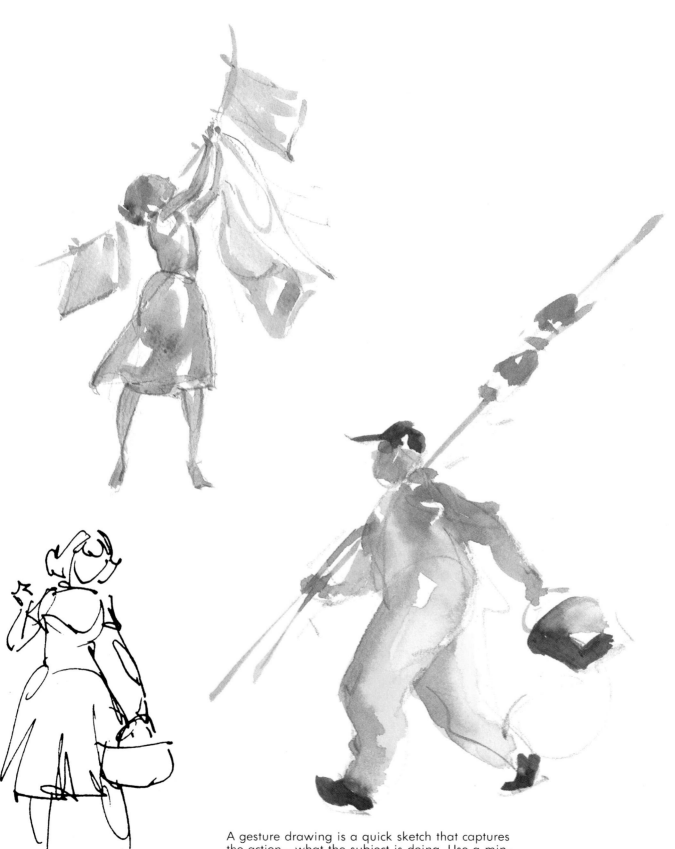

A gesture drawing is a quick sketch that captures the action—what the subject is doing. Use a minimum of lines, trying to have each line say a lot.

CHAPTER TWO

The Vital Gesture

Gesture drawing is the all-important first step in the development of believable figures for your paintings. In this initial stage, the character of the subject is described in terms of feeling, action, and identity.

Gesture drawing is usually done very loosely, almost like scribbling. As the pen or pencil or brush roams over the paper, you want to capture the feeling and action of your subject, drawing what it is doing, not just what it looks like. This feeling of action is more important than correct anatomy or correct proportions. A good gesture drawing crystallizes the essential expression of motion or activity. It's what makes the drawing look *alive*.

GESTURE:

the use of our body or limbs as a means of expression.

—Webster

Ordinarily there will be some dominant characteristic of the subject that will register at first glance. This initial impression is the thing to capture in your gesture sketch.

Sketch fountain pen.

Black Prismacolor.

Gesture drawings are done quickly and simply, almost without conscious thought. The procedure is to draw many small drawings as you attempt to record your first impressions. You want to capture the distinctive characteristics of the subject's stance, poise, or motion. Be concerned with the *feeling* of the subject rather than any specifics of anatomy or proportion. Many of the drawings might not look like much, especially in the beginning, but keep turning them out. Soon, your ability to get that "just right" feeling in your gesture drawing will rapidly improve.

Gesture drawing almost feels like it happens automatically, as if the pencil had a mind of its own as it moves over the paper. The pencil seems to find its own way. Actually, however, you are in the driver's seat, doing the drawing. The drawing is being formed, however loosely, from your knowledge of the human form.

Pencil plus watercolor.

Gesture drawings should be developed with whatever comfortable and convenient tool is at hand. If the pencil, brush, or pen responds easily and smoothly to your hand, the gesture figure will benefit.

Keep in mind, however, that the final figure will have to be rendered in the medium of your painting.

Carbon pencil is another good tool that gives rich blacks.

Pencil reinforced with sketch fountain pen.

Sketch fountain pen plus watercolor.

One difficulty with gesture drawing is that any part of the drawing may express the desired essence and yet not withstand the anatomical analyses and correction necessary to develop the figure further.

Use the subject's silhouette, as shaped by clothing, to give the figure its identity.

Gesture can't be analyzed or rationalized. Often gesture lines do not correspond to either contour lines or anatomical lines. More often it is a combination or interweaving of other lines flowing through the drawing that spells the action. At times, even the clothing—the swirl of a coat or skirt—can say it all.

These pages contain a random selection of sketches that I classify as gesture drawings. Some were actually preliminary studies for figures that were included in paintings, while others were just idle creations, born on the paper along the way, almost as a form of doodling. Study these drawings. Most of the drawings in this chapter were not one-shot efforts. Usually many drawings were done and discarded on the way to producing the final one that was right.

For further identity and feeling, try dropping color in on your loosely pencilled figure sketch.

Gesture drawings don't have to
be in black and white.

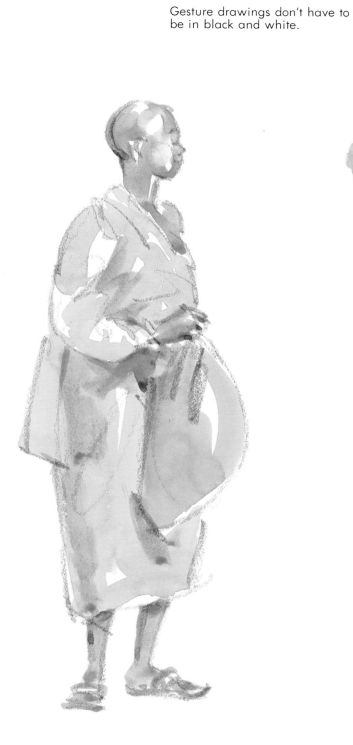

Carbon pencil plus watercolor.

Brush and ink—a good choice
when dealing with silhouette
shapes.

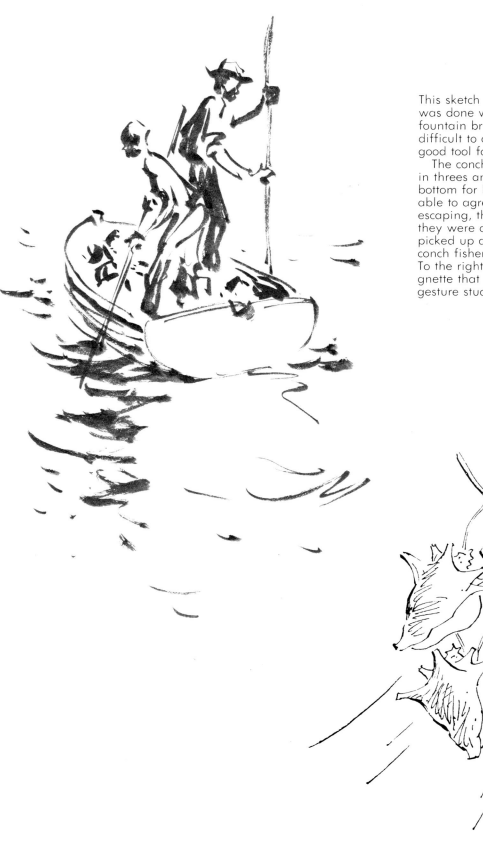

This sketch of conch fishermen was done with a Japanese fountain brush. Its soft tip is difficult to control, but it is a good tool for quick sketching.

The conch are tied together in threes and dropped to the bottom for later retrieval. Unable to agree on a direction for escaping, they remain where they were dropped, to be picked up days later at the conch fisherman's convenience. To the right is the finished vignette that was based on these gesture studies.

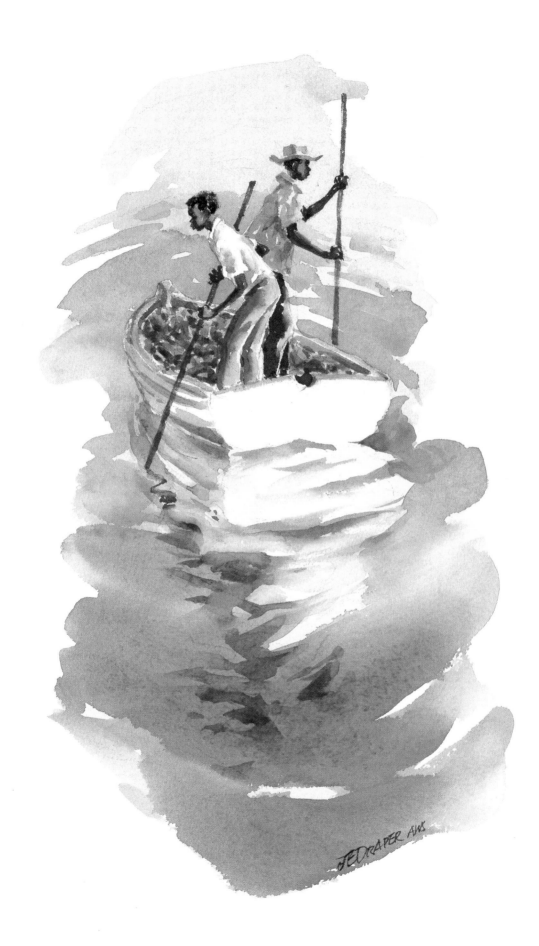

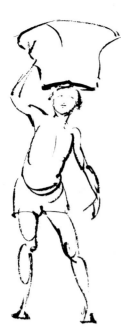

Gesture drawings should be re-
laxed and spontaneous, like a
scribble or doodle.

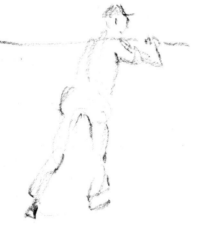

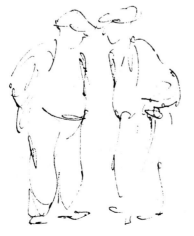

Spontaneity is essential to suc-
cessful gesture. Your gesture
drawings should be easy and
fluid responses to your subject.
They can't be forced; gesture
just happens. With practice,
you will acquire a natural
fluidity in your style. There will
be no resistance to the initial
impulse, which will flow onto
your paper.

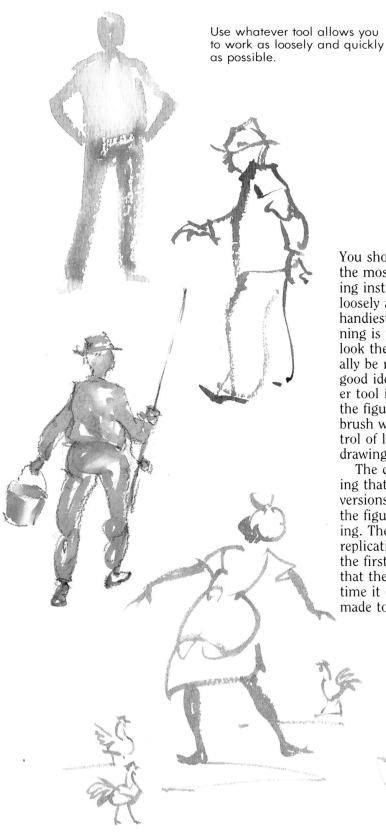

Use whatever tool allows you to work as loosely and quickly as possible.

You should work with whatever tool you feel the most comfortable with. Select the drawing instrument that allows you to work as loosely and freely as possible. The easiest, handiest, and best tool to use in the beginning is probably the pencil, but don't overlook the fact that the final image will eventually be rendered in a different medium. It's a good idea to practice with a brush or whatever tool is appropriate for the final version of the figure. A loaded, medium size watercolor brush with its soft point gives minimum control of line, but maximum spontaneity to the drawing because you have to keep it moving.

The challenge of gesture drawing is retaining that "just right" quality as you do more versions of the original drawing, developing the figure toward a finished stage in a painting. The difficulty lies in identifying and then replicating that intangible quality that made the first gesture drawing successful. It is said that the gesture line lives only once, the first time it occurs, and dies when an attempt is made to reproduce it.

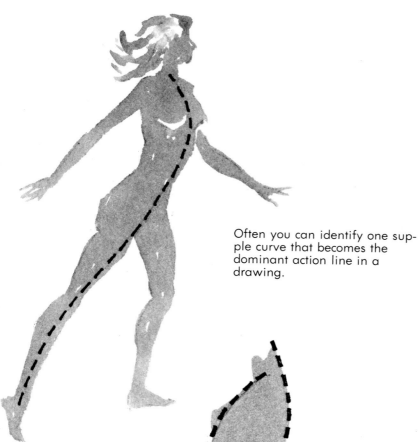

Often you can identify one supple curve that becomes the dominant action line in a drawing.

The dotted lines indicate a few of the major S-curves that flow through the body.

Knowledge of the natural curvature of the human form will help give your gesture drawing that "just right" quality. Although this curvature is largely a result of the curves of the skeletal structure, particularly the spine, the muscles are also arranged in a series of curves. Often these curves have a beautiful, alternating rhythm that gives the body its distinctive *human* character. Look for these curves and their rhythms and express them in your gesture drawings.

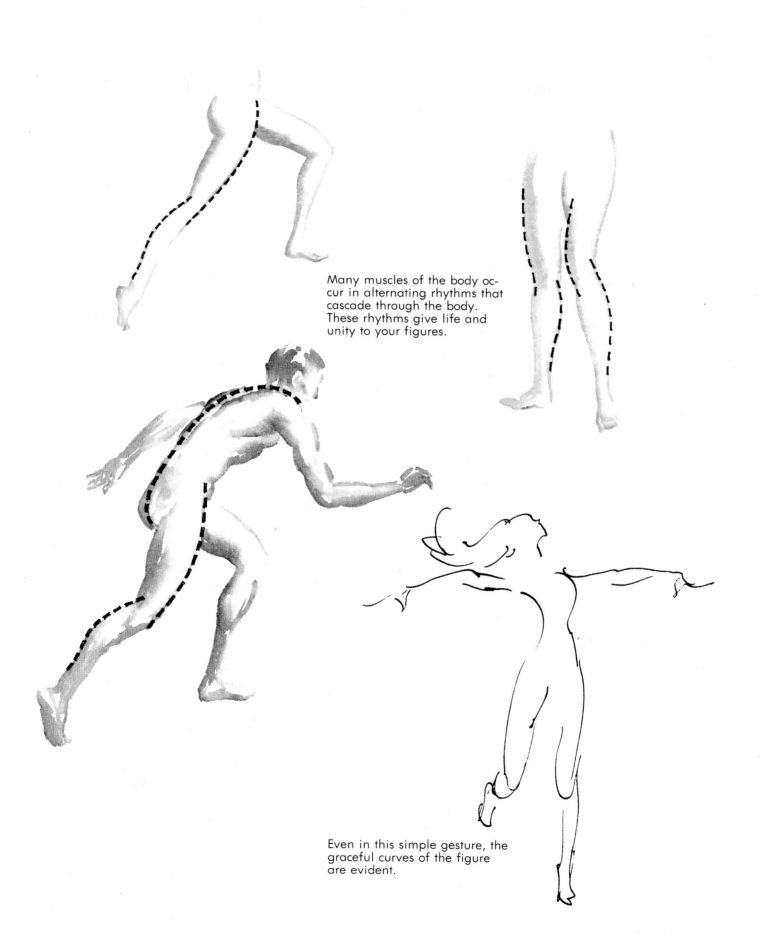

Many muscles of the body occur in alternating rhythms that cascade through the body. These rhythms give life and unity to your figures.

Even in this simple gesture, the graceful curves of the figure are evident.

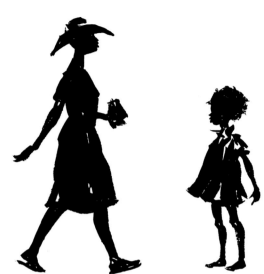

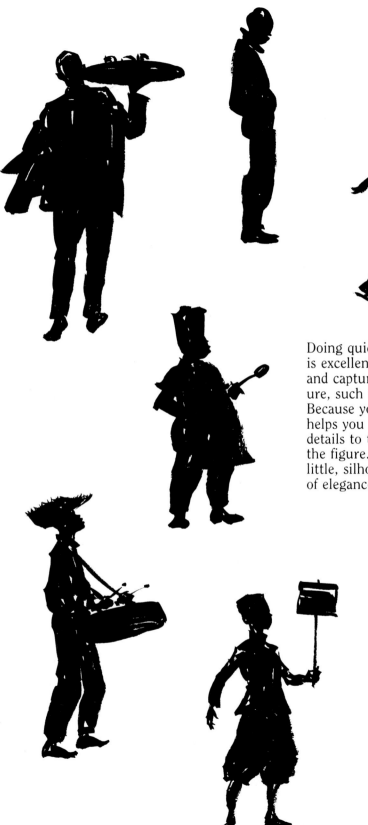

Doing quick brush and ink silhouette gestures is excellent practice. It forces you to analyze and capture the identifying aspects of the figure, such as the dominant curves of the body. Because you cannot include any detail, it helps you learn to see beyond the superficial details to the underlying action that identifies the figure. Because they say so much with so little, silhouette gestures have a special kind of elegance.

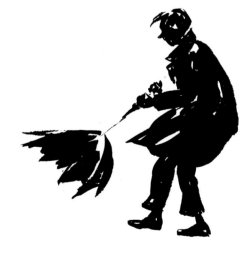

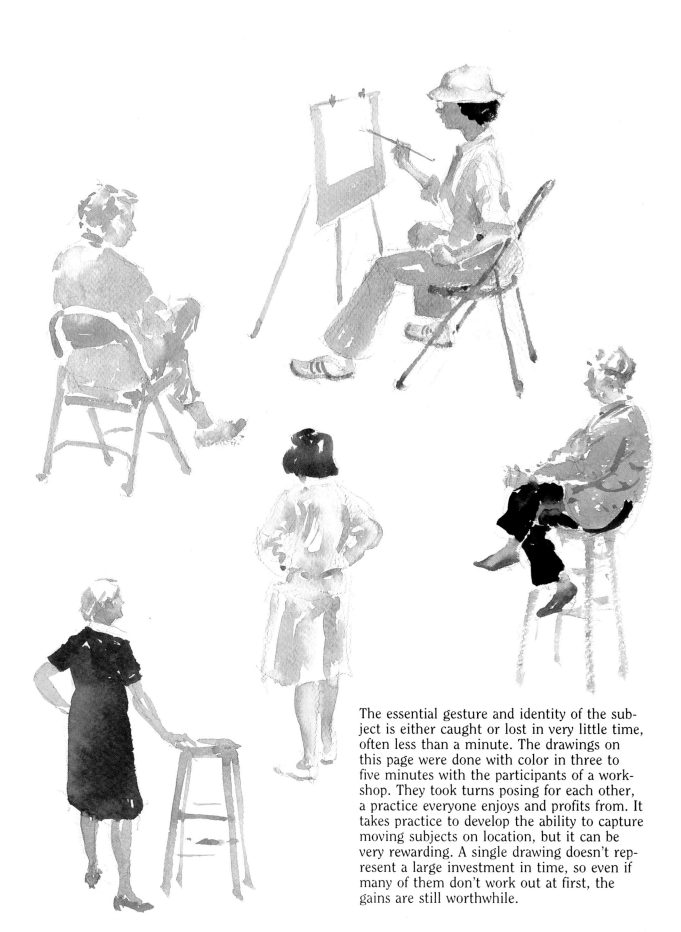

The essential gesture and identity of the subject is either caught or lost in very little time, often less than a minute. The drawings on this page were done with color in three to five minutes with the participants of a workshop. They took turns posing for each other, a practice everyone enjoys and profits from. It takes practice to develop the ability to capture moving subjects on location, but it can be very rewarding. A single drawing doesn't represent a large investment in time, so even if many of them don't work out at first, the gains are still worthwhile.

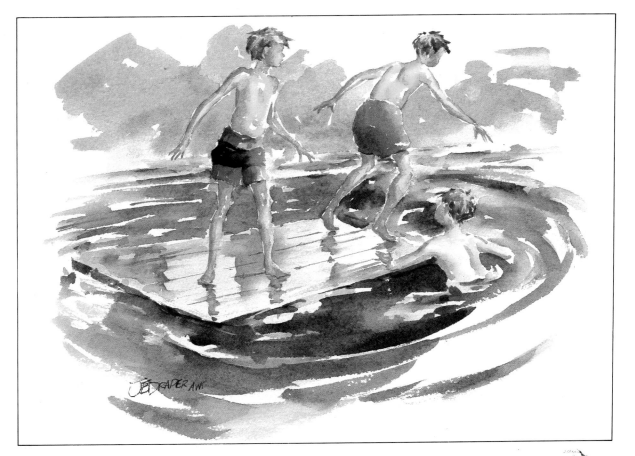

To sum up, gesture drawing is a quick sketch of the subject in action. Work loosely and spontaneously. Use whatever tools allow you to draw with a free-flowing line. Let your pencil move almost at will. Don't tighten up. Don't expect your pencil to do the same thing twice. Keep trying. It often takes many tries to achieve the right gesture, but each try sharpens your ability to distill the essence of a person in action.

I did these sketches at an abandoned stone quarry, a site of one of my watercolor workshops in Maine. These boys were using it as a swimming hole and were a natural part of the scene. Doing many quick gestures helped me capture this elusive quality.

Because children are so active, it is important to capture and retain this liveliness in your drawings. Even though the figures in the final painting are rather small, they must have a convincing sense of action.

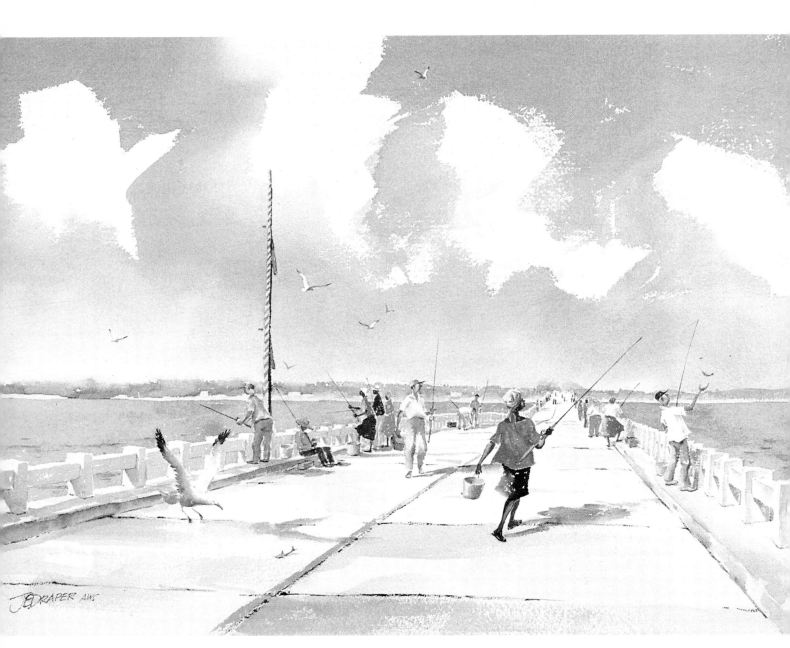

The painted figures on this fishing bridge began
life as simple gesture sketches, some drawn from
memory. The challenge is retaining the liveliness
of the original sketch in the final figure for the
painting.

CHAPTER THREE

From Gesture to Final Figure

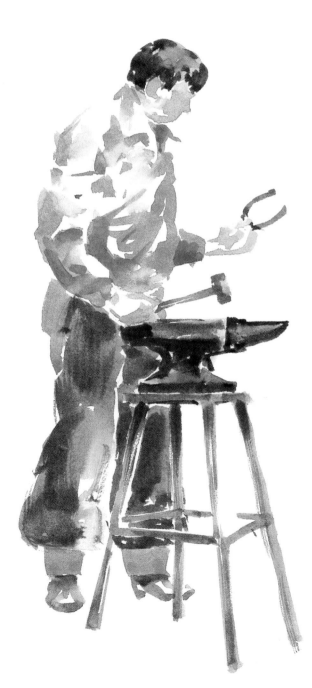

Since the gesture drawing represents the initial impression of a person destined to be used in one of your paintings, we will use it as a starting point in developing the final rendering. The challenge in going from gesture to final figure is to develop the original sketch to a degree consistent with the needs of the painting without losing the sense of action, identity, or character it contains.

The transition from gesture to final figure almost never occurs in just one step. Often there are several preliminary steps along the way. One of these steps often involves incorporating more accurate or specific information about anatomy. This is not always obvious, because the original gesture may not lend itself readily to anatomical analysis. Some of the best gesture drawings ignore the fine points of anatomy, with lines that do not correspond to the interior structure of the body. Sometimes there is a corresponding loss of convincing action when more correct anatomy is applied to gesture drawing. The best answer is a suitable compromise that retains as much as possible of the original energy without violating the reality of correct anatomy.

Shown here are several very loose gesture
drawings resolved into final figures suitably
developed for use in finished paintings. Notice
that there is a loss of gestural energy and the
feeling of spontaneity in the final version. It
is almost impossible to keep this from hap-
pening. A good gesture line has an intangible
quality that can seldom be worked on without
being diminished. In order for the final figure
to look spontaneous, the preliminary step can
be left incomplete and the final step painted
with as large a brush as is practical.

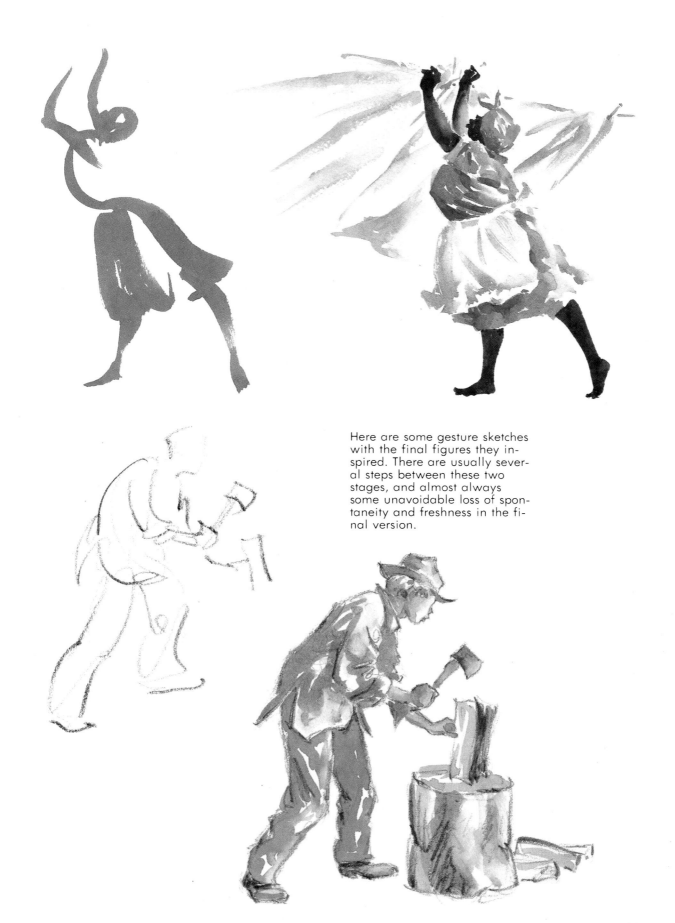

Here are some gesture sketches with the final figures they inspired. There are usually several steps between these two stages, and almost always some unavoidable loss of spontaneity and freshness in the final version.

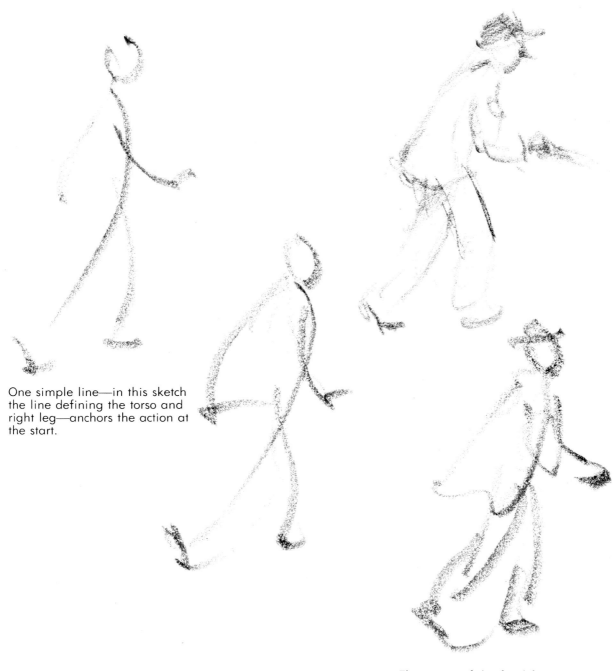

One simple line—in this sketch the line defining the torso and right leg—anchors the action at the start.

The action of the final figure is developed here, starting from the simplest pencil sketch. The action and the detail is developed simultaneously in the figure sketches that follow. Several others, not shown here, were discarded along the way. Separate sketches for each step are shown for the sake of clarity. Often in actual practice it will be easier to erase and make changes on the starting figure sketch.

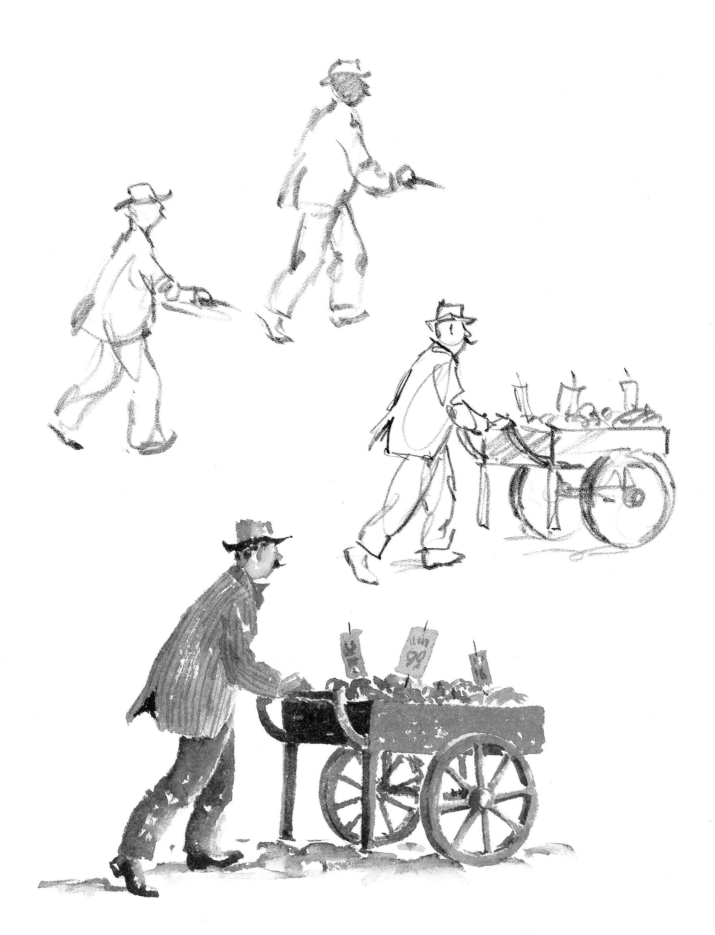

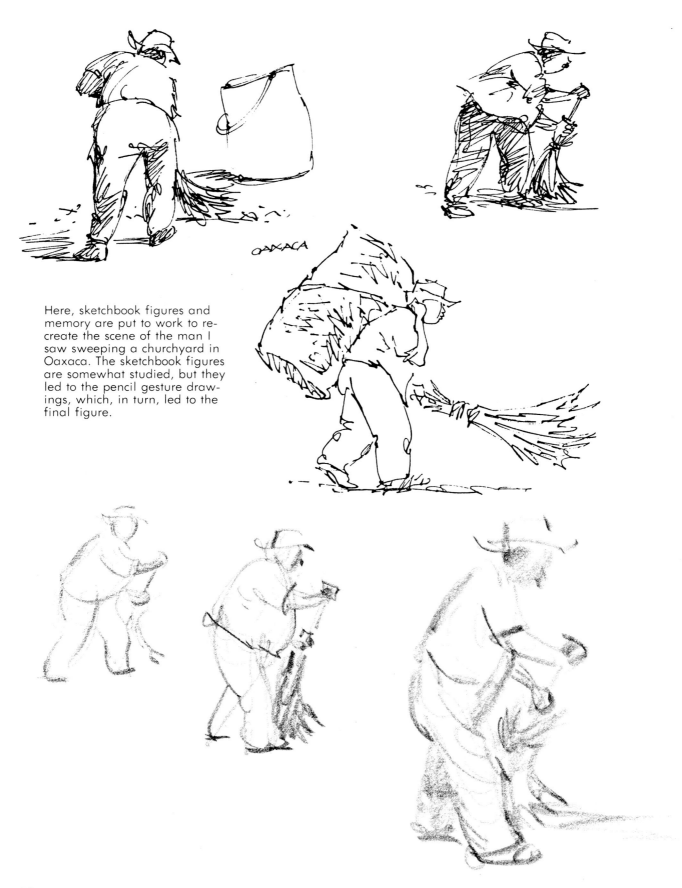

OAXACA

Here, sketchbook figures and memory are put to work to re-create the scene of the man I saw sweeping a churchyard in Oaxaca. The sketchbook figures are somewhat studied, but they led to the pencil gesture drawings, which, in turn, led to the final figure.

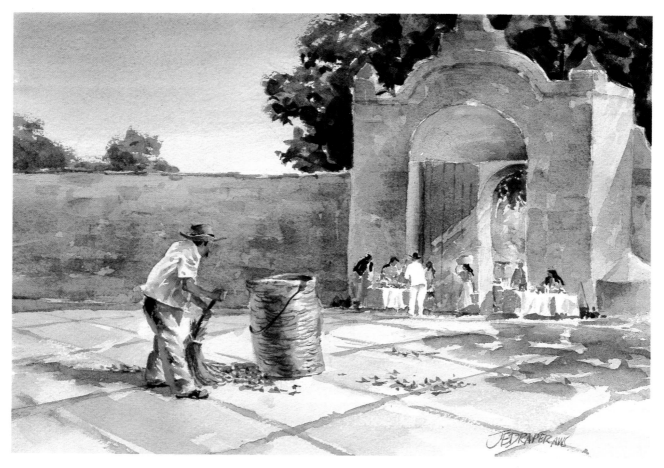

Oaxaca Churchyard

Following a workshop in Oaxaca, I produced this painting much later in the studio. Instead of using the yard and the gate as my subject, I decided to make it a setting for the figure of the sweeper.

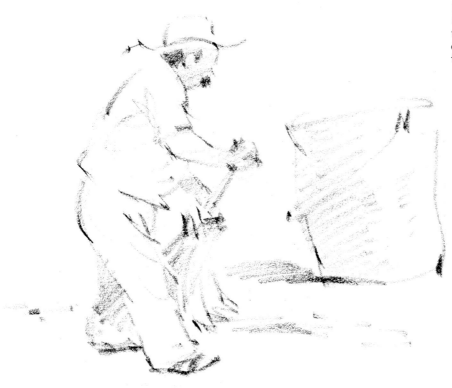

A figure 7½ heads high is considered by many artists to be the ideal.

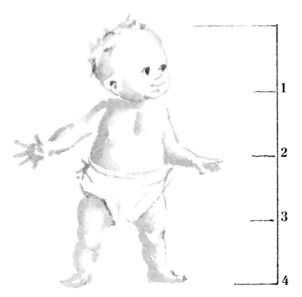

Toddlers of two are approximately four heads tall. During their growing years they progress, by degrees, to a final adult proportion of about seven and a half heads.

Arms and legs grow at a faster rate than the torso. This accounts for the "all knees and elbows" look during the early teens.

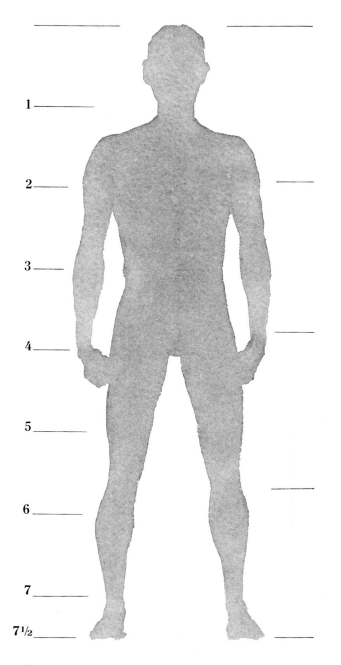

1
2
3
4
5
6
7
7½

The Facts of Life

Since there is some unavoidable loss of spontaneity and happy accident when a gesture drawing evolves into a final figure, we need to keep some important points about the human form in mind so the results are realistic and convincing. A few important facts—the proportions of the body, how it's constructed, and how it moves—will help us avoid a cartoon-like quality.

The most important concept for body proportions is head size. The average, well-proportioned adult is a little over seven heads tall. The accompanying chart uses a 7½ head figure as the norm, since to many artists, this proportion represents the proportions of the well-developed, slightly idealized adult.

The proportions chart shows the location of major divisions of the body according to head size. You can use this information as a handy guide when you develop figures for your paintings.

The general relationship of head size to overall height is a very important clue to the age of the person, since proportions vary with age. The head size of young children is larger in comparison to their overall height than the head size of the adult. A one-year-old is 4 heads tall (or long). As the child grows the proportion changes, until the child is about 7 heads tall in the midteens. Growth continues until the child reaches the 7½ head height.

If you want a figure to appear to be a child, don't just shrink an adult figure down to size without enlarging the head size appropriately. Likewise, a large head on an adult size body will make the figure look childlike. Another fact to keep in mind when drawing young people is the gangly "all knees and elbows" look during the growth years. A child's legs and arms grow at a faster rate than the torso.

As you produce figures and add them to your paintings, checking their proportions constantly should be a number one priority. Even a slightly wrong head size can create a misproportioned figure, turning a child into an adult or vice versa. Be very careful in the beginning until you develop a good eye for proportions.

Figures of young people should usually look active. Depicting this action properly is important. Their constant, effortless action is the thing that says they are young.

These are young boys, ten to twelve years old. It is important not to make them seem older. They should look like young boys, not small adults. This is mostly a matter of proportion, proper head size, and not too much upper body development. Keep necks and shoulders thin.

Sticks and Bones

Artistic anatomy can be a complicated and somewhat intimidating subject for artists interested only in creating small figures for populating landscapes. For our purposes, an informal study of the body's structure is all that is necessary.

Let's begin with a very easy to understand stylization of the body's structure in the form of the stylized stick figure. Despite its simplicity, the stick figure can contain a great deal of anatomical information for the artist. In general, the lines and shapes of the stick figure correspond to the body's inner framework, the skeleton. Of particular importance to the artist are the rib cage, pelvis, and the big curves of the body.

The most important, dominant curve is that of the spine. The spine exhibits an S-curve that distinguishes the human body from other creatures, even the apes. Basically, the body is composed of three major solid masses—the head, the rib cage, and the pelvis, connected by the flexible column of the spine at the waist and neck. We can bend and twist at the waist and at the neck, changing the disposition of head, rib cage, and pelvis.

The stick figure, or the simplified skeleton figure, is the best way to get started. It is a means of working out the action of the figure and checking proportions before getting to the finished figure.

The elbow falls just below the rib cage.

Give legs their proper look, even in a stick figure. Note the forward convex curve of the upper leg, the concave curve of the lower leg, and the offset of the upper and lower leg occurring at the knee.

The head protrudes to the rear more than to the front.

The neck emerges forward of the shoulders.

These two easy to draw shapes, representing the basic shape of the pelvis and the rib cage, work best for me. Practice drawing them and putting them to use in your stick figures.

The range of movement of these body masses limits the number of possible poses and positions of the body. A familiarity with the possible motions and an awareness of the curves that produce them will help you make convincing figures in believable poses.

When you are doing gesture studies of the human form, draw the curve of the spine and identify the solid masses of the body until you can recognize them automatically.

The other important lines in the stick figure are those corresponding to the long bones of the skeleton. Notice the direction of the gentle curves in limbs. There are no straight lines. The body is composed of graceful, subtle curves that give a lifelike quality to even the simplest of stick figures. If you straighten these lines out, suddenly the figure looks stiff, ungraceful, and mechanical. Again, in your gesture studies, you may want to exaggerate these curves slightly so you don't lose them in later developments.

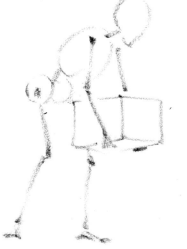

Less simple and stylized than the stick figure is the schematic skeleton figure. This figure retains the "spring" of the stick figure in its curvature, but adds more information about the pelvic structure and musculature. Notice how the pelvis is simplified into two disklike shapes with the hip socket as an "axle." The chest, back, and shoulder muscles form a kind of cape that gives the upper body its bulk and form.

For practice, try converting your gesture studies into stylized stick figures and into schematic skeletons. This will help you "see" the big curves of the body and the inner structure beneath the mantle of flesh and clothing. Eventually, this information will unconsciously leak into your gesture drawings as you learn to "see" these features when you draw from life.

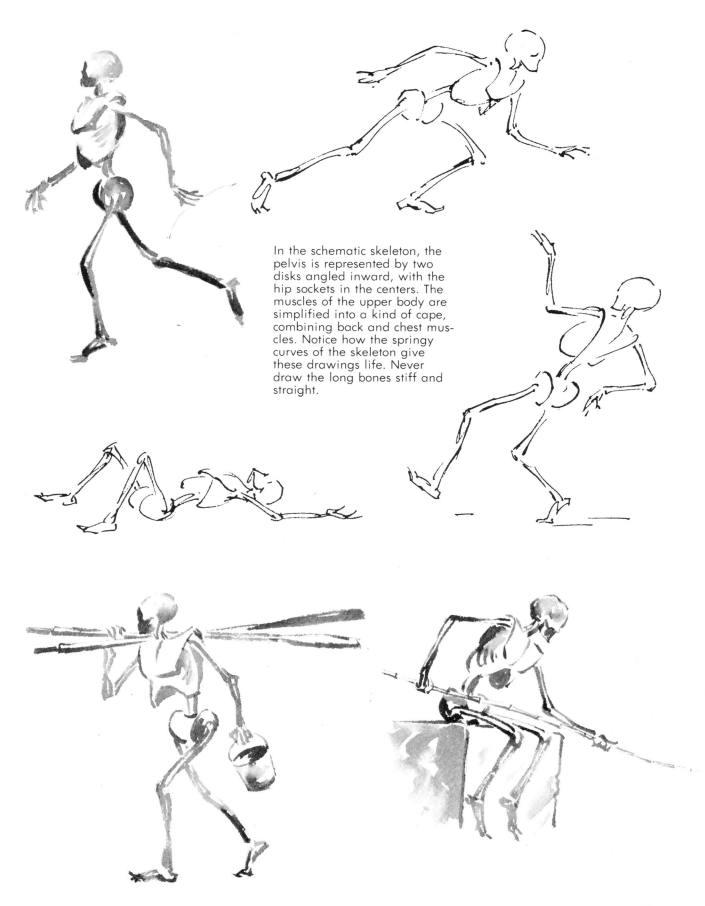

In the schematic skeleton, the pelvis is represented by two disks angled inward, with the hip sockets in the centers. The muscles of the upper body are simplified into a kind of cape, combining back and chest muscles. Notice how the springy curves of the skeleton give these drawings life. Never draw the long bones stiff and straight.

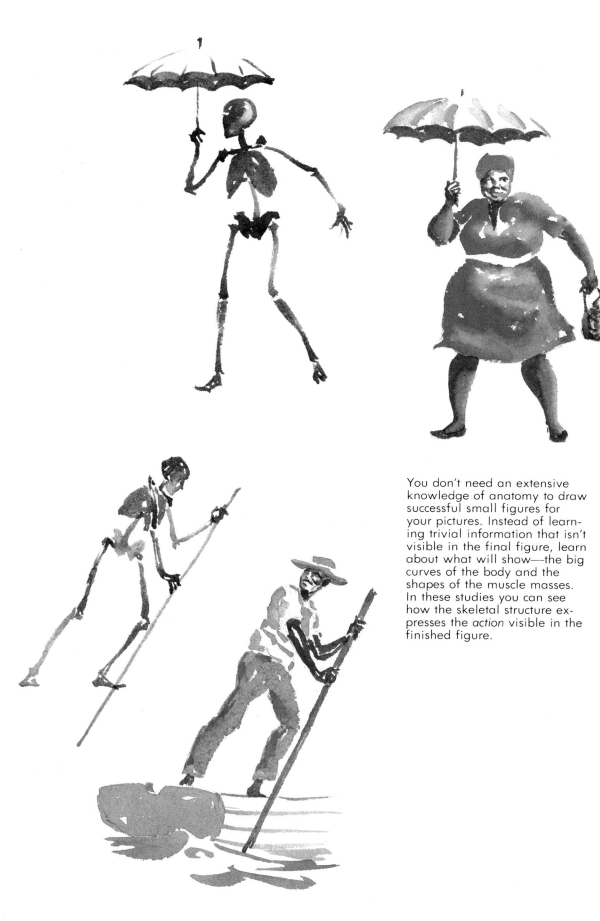

You don't need an extensive knowledge of anatomy to draw successful small figures for your pictures. Instead of learning trivial information that isn't visible in the final figure, learn about what will show—the big curves of the body and the shapes of the muscle masses. In these studies you can see how the skeletal structure expresses the *action* visible in the finished figure.

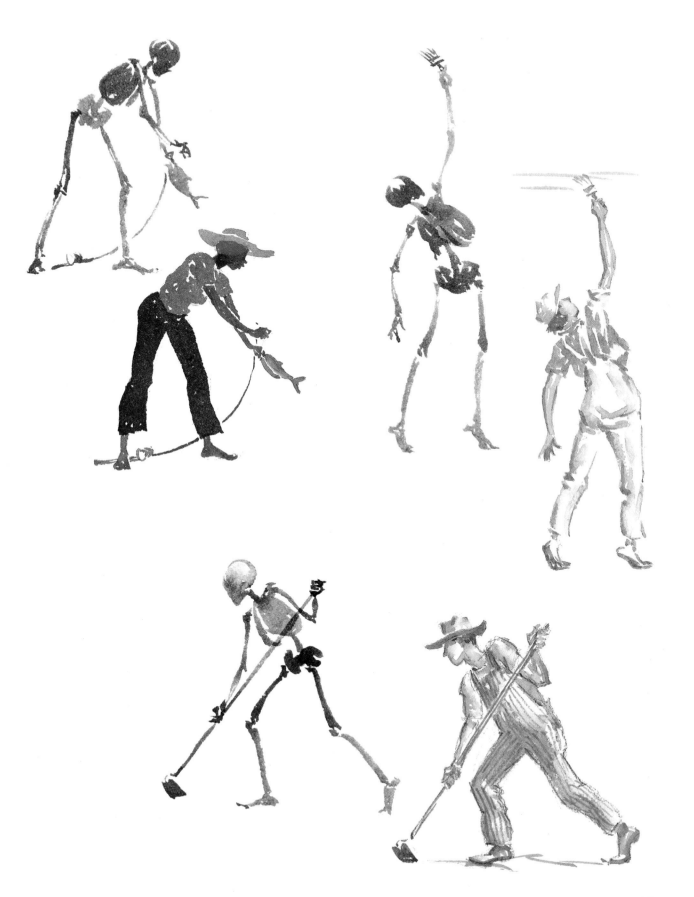

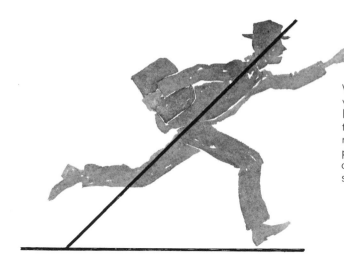

When a person is moving, walking, or running, this same line will tilt in the direction of the movement. The walking or running person is always in the process of falling forward, recovering its balance with each step.

Figure Movement

Both the stylized stick figure and the schematic skeleton tell us much about how the body moves. While walking, running, or merely shifting from one comfortable position to another, all body parts interact with each other. Although this interaction is quite complicated from a sports-medicine point of view, the artist needs to know only a few simple facts.

When the body is not on the move, a line from the head down through the center of gravity is vertical. The weight of the body is supported and remains stable. If the weight is all on one foot, the vertical line will drop through that foot. If the weight is distributed to both feet, the line will drop somewhere in between, but always through the center of gravity.

Note the forward, leaning movement of the two men carrying their heavy load.

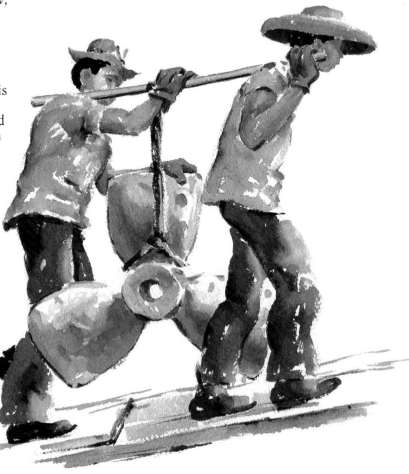

The juncture of the spine and shoulders is not rigid but quite flexible. However, the body angle and the line of the shoulders tips in the opposite direction to the pelvis.

The spine recurves to maintain balance.

The right leg is bearing the weight, thus raising the right hip and tilting the pelvis.

The juncture of the spine and the pelvis is a rigid right-angle joint. When the pelvis tips, the spine is forced to tip also.

If the weight is all on one foot, the vertical line from the head down through the center of gravity will drop through that foot. If the weight is distributed partially to the other foot, the line will drop somewhere in between.

One basic interaction involved in almost every move the body makes is the counterbalancing action of the pelvis and shoulders. The spinal column joins the pelvis by means of the sacrum, forming an immovable right-angle joint. When the pelvis tips as the weight of the body shifts to one hip, the spinal column tips with it. The upper part of the spinal column automatically recurves to bring the upper body back over the center of gravity, lest the body fall. The spine curves in opposite direction to the shifting hips. The shoulder line tips in the opposite direction to the pelvis.

This hip and shoulder relationship is maintained in any position the body assumes. Often opposing angles of the hip and shoulder are minimal to the point of being unnoticeable. However, when it is noticeable, check to make sure the hips and shoulders are not tipped incorrectly.

When a person carries weight, it affects his balance and vertical alignment. A vertical line through the center of gravity will move according to the distribution of the weight above. Not knowing just how heavy his load is, we look for telltale clues, such as how far the body must lean to counter the weight.

Another bit of action sometimes depicted incorrectly is the reciprocal action of the arms and legs as a person walks or runs. Very simply—when the right foot goes forward, the right arm swings back, and vice versa.

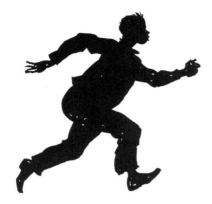

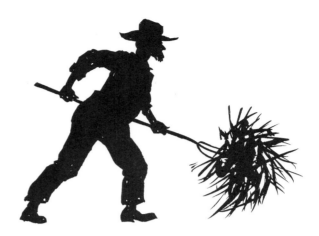

The importance of well-thought-out silhouette shapes cannot be overemphasized. The figure in your painting may not always be silhouetted in the sense of being backlighted. It may be frontlighted and have a broken-up color pattern but, in small figures especially, it will be the overall outline shape that will convey the identity and depict the action, saying what the figure is doing.

The Silhouette

One of the most critical aspects of any figure drawing, especially for the small figures placed in landscapes, is the silhouette shape of the body. If the shape of the body is correct, the figure will work well regardless of how the smaller details are handled. The silhouette shape will identify the figure. If the silhouette is not correct, no amount of correct detail inside the shape will save it.

All the points we have discussed so far—proportion, structure, and movement—affect the silhouette. Correct proportion is immediately apparent (or not apparent) when the body is considered as a flat shape. The big curves of the body are also important, since they make the figure appear human rather than mechanical. The silhouette will also reveal the counterbalancing of the pelvis and shoulders and the way the body leans into the direction of motion. It's often easy to forget the importance of checking the silhouette for correct proportion, curve, and motion, but it is vital to the success of the figure.

Here are several examples of silhouette shapes of people doing things. Study them and practice creating your own.

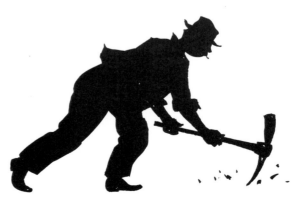

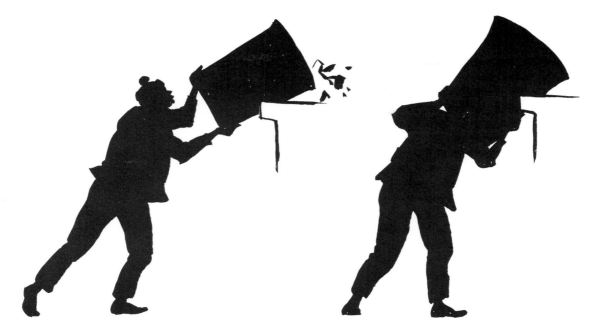

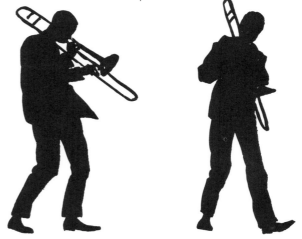

The silhouette of the body will be clearer and more expressive from some points of view than others. Seen from certain angles, the shapes of the body overlap to form a meaningless shape that does not convey identity, character, and action. Select the most telling angle for your figures. Don't hide any important body parts inside the shape. Experiment with different angles to find the clearest one. Slightly exaggerating the posture or pose might also be necessary to communicate what the figure is doing. The original gesture drawing may provide important clues about what features best characterize a subject's action. Finally, don't forget important tools, clothing, or accessories that further identify who the figure is and what the figure is doing. For instance, the silhouette of a hard hat or top hat would clearly distinguish the activity of the figure.

Make sure that what the basic figure is doing is not obscured by poor positioning. If it is important that the subject be shown performing a certain action, then the silhouette shape must convey this.

A person can be performing a certain task, using a tool that could identify the task, but be positioned in such a way that none of this is evident in the silhouette shape.

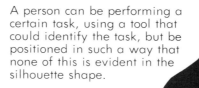

The Blob Torso

One important aid to achieving a correct silhouette is what I call the "blob" torso. I find the torso is often the best place to start. For this you can use a blob that can be shapeless or shapely or anything in between. It almost immediately starts me on the type of figure I want. These shapes can be bent or twisted as a start for the figure action. Once legs, arms, and a head are added, all that remains is to check them against the facts discussed above. You won't want to use the blob torso all the time, but it's a good way to get a figure started.

The blob torso can be almost any rounded shape. Often a kidney shape works for side views.

From a practical standpoint, you won't be able to think of every one of the preceding ideas or check every fact each time you construct a figure. This would make building a figure a tedious and boring operation and would destroy that all-important sense of spontaneity that makes the figure come alive. With a little practice your eye for body proportions and action will develop and become more natural and reliable. As this happens, your roughed-in gesture drawings will provide a more solid beginning for developing finished figures. Remember, head size as the basis for proportion, the "lean" of the body in action, and the clarity of the silhouette are the most important things to check for. If anything doesn't look right, turn to the facts in this chapter and consult the figures here as a means of checking and correcting.

The blob torso does not have to result in a large figure. Here we see three "blobs" that could be the basis for children.

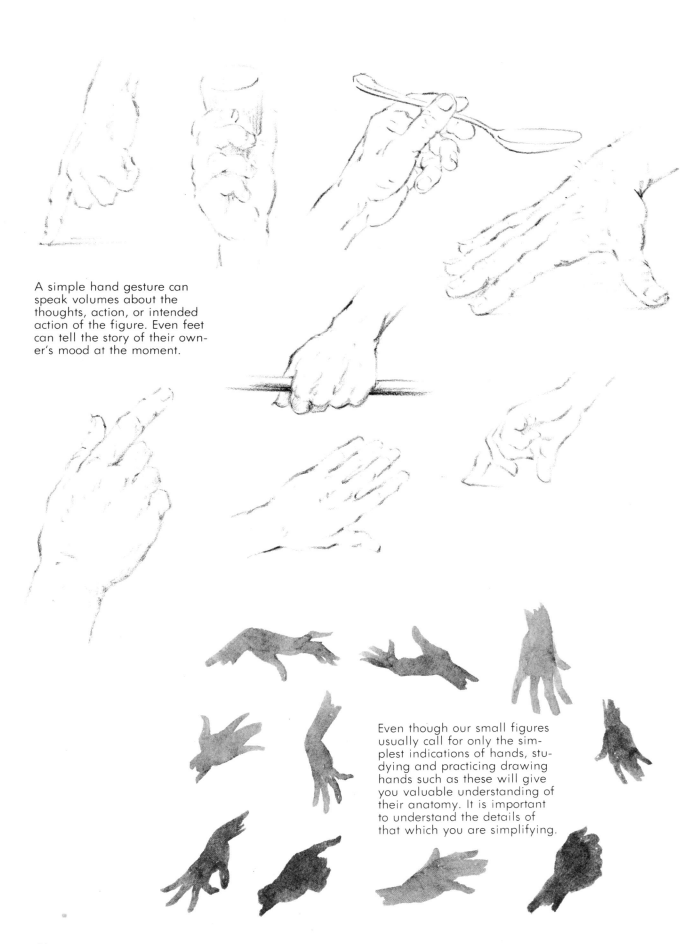

A simple hand gesture can speak volumes about the thoughts, action, or intended action of the figure. Even feet can tell the story of their owner's mood at the moment.

Even though our small figures usually call for only the simplest indications of hands, studying and practicing drawing hands such as these will give you valuable understanding of their anatomy. It is important to understand the details of that which you are simplifying.

Details

Since your purpose is to create small figures that are intended to be incidental characters in your pictures, you won't need to master many fine details. Most details will be mere suggestions. Your job is to simplify. The mass of details presented by your subject matter must be reduced to the essential features in order to communicate the figure's identity and activity, but not much more.

However, in order to simplify the figure correctly, it's necessary to have a knowledge of what you are simplifying. For instance, a hand is an important part of the overall gesture of the figure, even though it may be represented by a tiny flick of the brush. Your understanding of its shape and attachment to the figure should be built into that tiny brushstroke.

This is true for other details. Eyes, nose, feet, and all the other parts of the figure are part of a whole. They must be handled together. Any one of them can change the basic character of the figure you are painting.

Study the details on these pages. Practice drawing details from life or from photographs, until you have a mental repository of useful details in your memory. Often when sketching, your subject will "pose" for only a short time before moving on. You won't have time to capture more than the fleeting gesture. But you can rely on the file box of details stored in your head for completing the figure effectively.

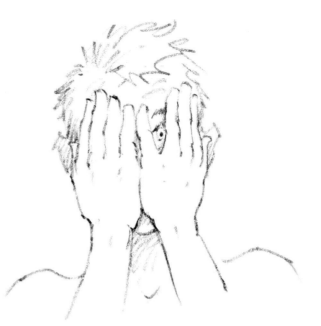

The size of the hands is such that they just cover the face.

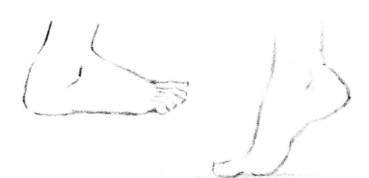

One important and difficult aspect of drawing the foot is making the foot appear to be flat on the ground.

The shape of the sole of the foot on the ground is an important start. Try laying a pair of innersoles on the ground and drawing them from various angles and heights. Following this, graduate to drawing shoes in the position you'd see them if someone were wearing them.

Of course nothing beats drawing from the live model, but innersoles and shoes are more available.

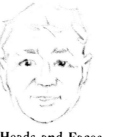
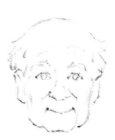

Heads and Faces

Most artists find the head and face to be the most challenging part of the figure. Because we are so utterly familiar with the face, we are sensitive to very subtle details of expression. The best way to master the face and head and to overcome any fear of including them in your painting is to do many, many small head studies.

I don't do portraits, but I do like to do head studies. If the head study results in a likeness, so much the better, but that is not my primary goal. I want my study to say something about the subject as a type of person, rather than as a specific individual. These head studies frequently do result in a likeness satisfactory to me, and sometimes even to the subject.

In drawing heads, I prefer to start with a gesture approach. This allows me and my pencil to sense and feel out whatever quality of the subject is desired. The gesture approach provides a foundation for further drawing.

In the gesture approach, when the subject is a baby or a very young child, you are thinking smoothness, roundness, and softness. As the subject grows and develops through childhood, adolescence, maturity, and old age, the drawing approach takes on other things. First the bone structure makes itself known, and the jaws and facial bones begin to shape the individual. The process continues into the teens, during which the adult head and face proportions are achieved. Then a gradual maturing takes place. Softness and roundness give way to angularity and firmness of features. So-called "character lines" are formed, as time continues to bring on wrinkles, creases, and sagging of the jowls.

When I'm painting facial features on a small figure in a painting, I make sure the amount of detail is appropriate for the size of the figure and its relative importance to the others. Faces naturally attract attention, and I don't want the viewer's attention diverted from a more important part of the painting.

As shown in the three sketches above, the infant has more roundness, softness and a larger ratio of cranium to facial area.

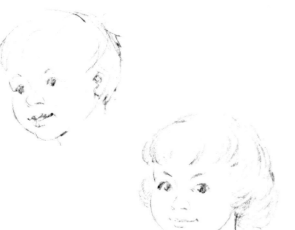

As more growth occurs, the bone structure becomes more evident. The proportion of facial area to cranium begins to increase. Final adult proportions will be reached during the late teens.

As age begins to take its toll, what happens varies with the individual. Lines that used to appear and disappear with expression changes become permanent wrinkles and creases. Cheeks sag to become jowls, neck tissue hangs loose, and more and more wrinkles appear.

For the figures in our paintings we are usually more concerned with the whole body than just the faces. In fact, we seldom show more than just a suggestion of facial features.

For this reason, when depicting an elderly person, we must rely on the silhouette identification using certain visual features to depict age. The primary feature is the no longer erect posture. Another, if it can be managed, is the unsteady gait or stance, possibly with the use of a prop such as a cane.

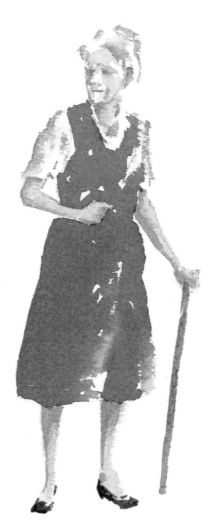

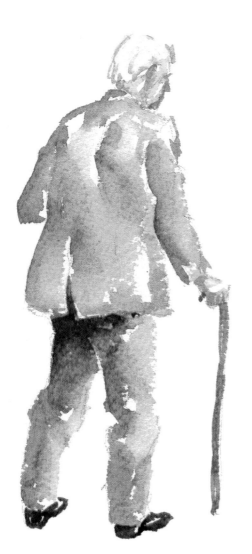

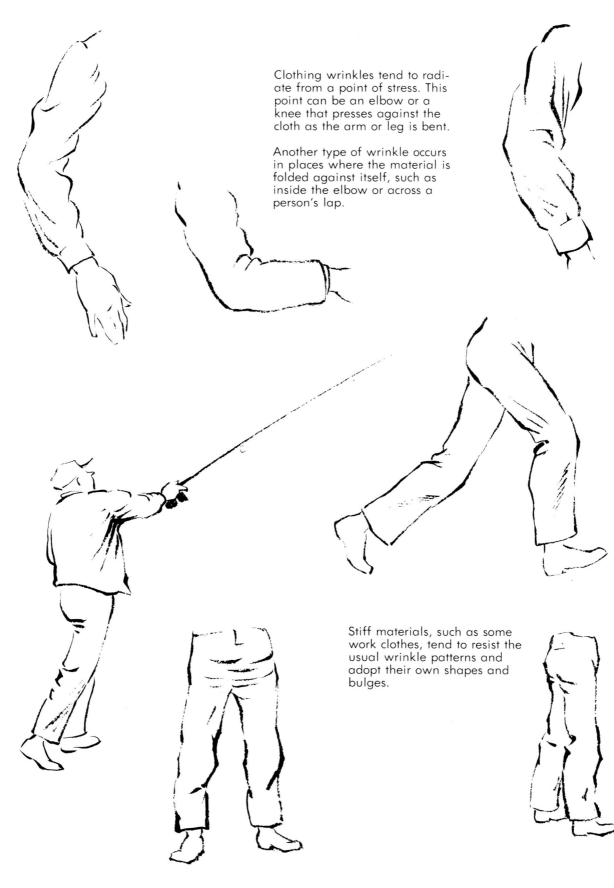

Clothing wrinkles tend to radiate from a point of stress. This point can be an elbow or a knee that presses against the cloth as the arm or leg is bent.

Another type of wrinkle occurs in places where the material is folded against itself, such as inside the elbow or across a person's lap.

Stiff materials, such as some work clothes, tend to resist the usual wrinkle patterns and adopt their own shapes and bulges.

CHAPTER FOUR

Making the Figure Fit

Once we have gained some confidence in our ability to create acceptable small figures, it is time to start putting them in our paintings.

The painting can be thought of as a habitat or environment for the figures we are producing. The variety of settings our figures may find themselves in is endless. They may be indoors or out, in darkness or light, in the country or the city or on board ship, and they may be doing an unlimited number of activities.

Our figures must be able to take their places in the paintings and become an integral part of the scene. They need to fit in. A figure could be perfectly proportioned, shown in the midst of a convincing movement, and have all its details correctly painted, and still not look like it belongs to the painting.

In order for a figure to look natural or comfortable in a painting, it must fit the mood of the picture and have the right amount of emphasis for its role in the situation depicted. It must be painted in a technique consistent with the rest of the painting. The lighting on the figure must be right. It must be scaled correctly so it is the right size for its surroundings.

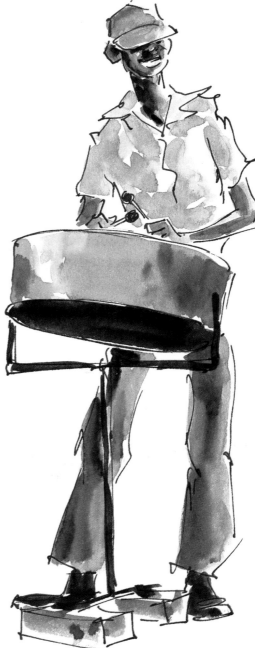

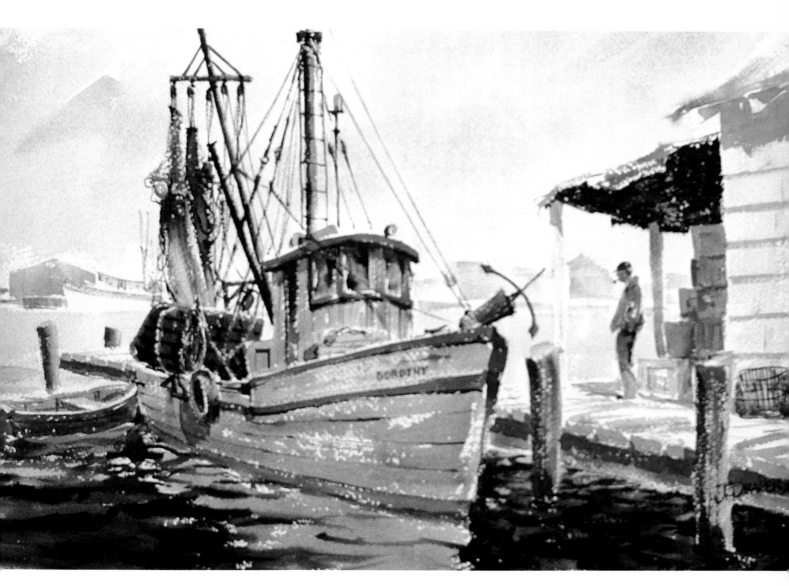

The Dorothy

The boat is the center of interest in this composition. The figure adds a bit of human interest and keeps the picture from looking oddly abandoned. The figure is the secondary interest. It is kept simple with few details so it doesn't compete with the fishing boat.

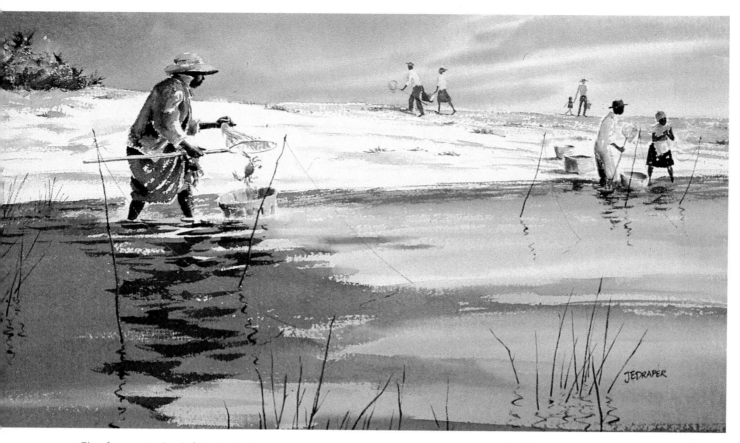

The figure to the left is both the center of interest and the focal point of the composition. The composition was designed to lead the eye to her.

Crabbing at Guano Lake, Florida

The Right Mood and Emphasis

All figures become important elements in the composition of a painting. Composition is the art of designing a painting or structuring it in such a way that the viewer will scan the picture in certain patterns. Usually the eye is attracted to certain areas of the picture that act as magnets for the viewer's attention. These areas are called focal points. They act as resting points where the eye lingers on its journey through the picture.

Any figure in a painting automatically demands attention and thus tends to become a focal point, even when not intended. Therefore, the placement of the figure in the painting should be considered carefully when the composition is planned. Ideally, the figure or figures in a painting should be part of the original concept of the painting. Occasionally you will need to add a figure to a painting al-most as an afterthought or a finishing touch because the finished painting lacks that spark of life, but it works best if the figure is planned for a picture from the beginning.

Because the figure tends to be a strong focal point, there are a number of things to consider when placing a figure in a painting. First, the focal point or points of the painting should be determined; they may or may not be the figure. The intended focal point should contain the strongest value contrast, creating the strongest attraction for the eye. Other areas of contrast should be kept subdued. Since the figure is a natural attention getter, it can be used to reinforce the focal point or actually be the focal point. If the figure is an incidental element, then it should be low contrast. Otherwise you may end up with competing focal points cancelling each other out.

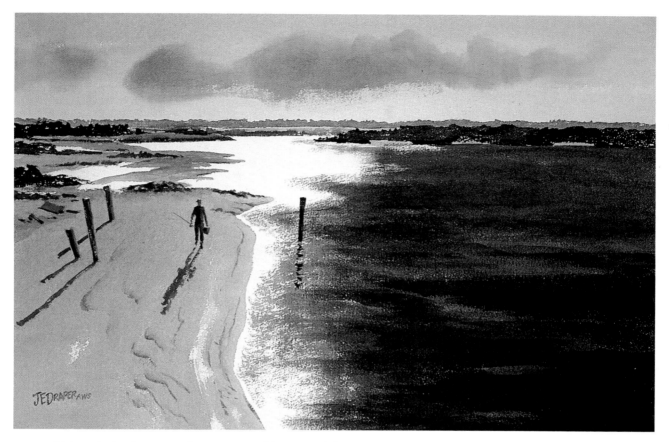

Although the figure in this painting is small, it acts as a powerful magnet for the eye. The fisherman is shown heading home, which enhances the overall mood of a day's end.

Matanzas Inlet
Collection of Colonel and Mrs. Anthony R. Parrish

The figure in this painting is shown in the midst of everyday activity, yet imagine how dull this picture would be without him.

Lobster Traps, Florida Keys

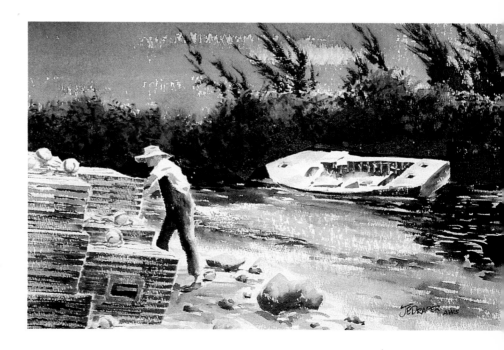

These vignettes are finished studies executed in the same style and technique that I use for a complete painting. They are complete in themselves, but could very well become part of a larger painting with little or no change.

Technique

The figure should be painted with the same style and technique as the rest of the painting. Even if the preliminary studies that developed the initial gesture into a usable figure may look different or be executed in a different medium, the final version should match that of the painting. As you work up the figure, the last steps should be done in the correct painting medium.

My favorite technique for these last steps is accomplished with the brush with loose washes of color over a preliminary pencil drawing. The preliminary drawing, though based on previous gesture studies, simply indicates size and placement. The liveliness of the resulting figure is the product of the lost-and-found quality of the loose, spontaneous brush handling, which is basically the same as gesture drawing with the pencil.

Another useful technique is a combination of line drawing and wash. This gives a tighter, more linear look. This treatment must be compatible with the rest of the painting. The danger is the temptation to rely on the contour lines for clarity rather than using differences in value.

Line and wash is one of my favorite techniques. If I use this technique for a figure, I will use it for the rest of the painting as well, so the figure looks like it belongs.

Line only—This is an interesting technique but has little application in doing a painting.

Incidentally, these are usually done over a roughly indicated pencil gesture sketch, such as shown here. This gesture sketch usually indicates nothing more than the action and general character of the figure.

In the final pen drawing, the pen does its own thing and no attempt is made to follow pencil lines.

These small figures could be placed almost unchanged into a painting of the appropriate setting. Your figures should populate your pictures without looking like they stand out.

Lighting

The placement of values will be determined largely by the location of the light source. Check to make sure the figure is lit from the same direction as the rest of the painting. A figure lit from the other side will surely attract the wrong kind of attention. It's a simple matter to remember and makes an enormous difference.

Objects in shadows have reduced value contrasts. In watercolor, this is easily accomplished by covering the shadow areas with a uniform shadow tone before painting in other colors or details. A medium wash of light blue-gray can be painted over the parts, objects, or figures in the shadow. Then the other colors are washed on right over the areas in and out of the shadow.

For a figure lit from behind, such as when it is seen against the light background of the sky, the entire figure should be covered with a neutral wash to create a solid silhouette shape. This is followed by the colors and details inside this shape. The overall shadow wash insures the figure will have a correct and consistent value within the shadow area and will be subdued to a uniform degree.

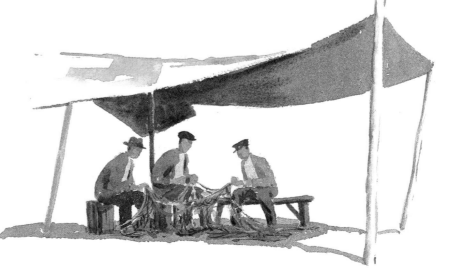

In the example above, two of the seated figures are in the shadow of the boat and one is partly in the shadow. The woman is in full sunlight. As a first step, a medium strength wash of blue gray was put over the shadow side of the boat and over the figures except for the head and shoulders of the one figure.

This same treatment was applied to all the figures in the shade of the tarpaulin, below.

When the light is coming from behind the figure, such as when it is seen against a sky background, it must have a total silhouette value regardless of any light colors on the figure.

To insure this, wash in the entire figure with a neutral tone, as shown at far left. Then follow by painting in the colors over the tone, at left. The figure will then have an overall correct value against the light. All the colors are subdued to a uniform degree as they would be under the conditions depicted.

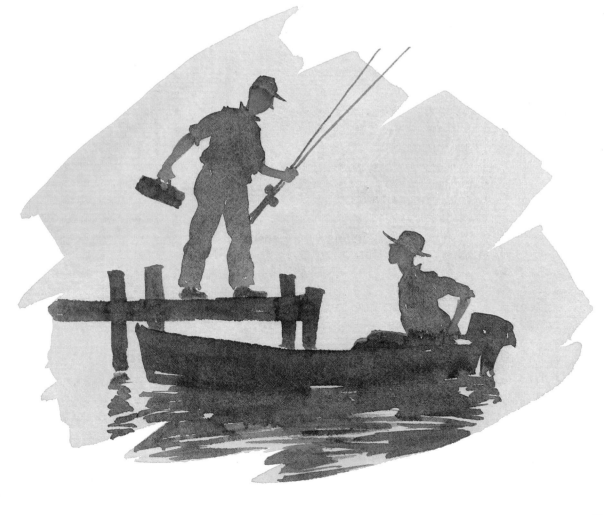

Reflections

Reflections can be a very important means of adding sparkle and life to a painting. They are great for brightening an otherwise dreary subject. In landscape scenes involving bodies of water as small as a puddle or as large as the ocean, nothing can make a wet surface look better than properly executed reflections. Even a street scene can be dull and boring until you decide to add some wet pavement to reflect the images and colors of lights, cars, and people. However, without a few guidelines, your reflections won't be very convincing.

First, all reflections on a level surface of water or any other reflective material fall on a vertical line directly below the object being reflected. A reflection never strays off to either side. Second, reflections on irregular surfaces, such as rippling water, are often lengthened greatly by the irregularities. For instance, the reflection of a light on a far shore of a lake can extend all the way across the water down a vertical line to the feet of the observer. Third, a reflection is an upside-down mirror image that begins where the object is in contact with the reflective surface. Often there are intervening objects which may hide part of the reflection. Finally, water surface ripples break up the reflected image. The artist might take advantage of this and keep the drawing of the reflection simple.

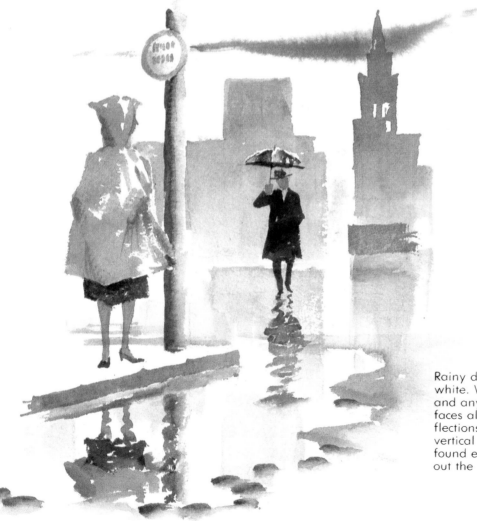

Rainy day skies tend to be white. Wet pavement surfaces and any upward facing surfaces also tend to be white. Reflections indicated by means of vertical strokes with lost-and-found edges do much to carry out the feeling of wet surfaces.

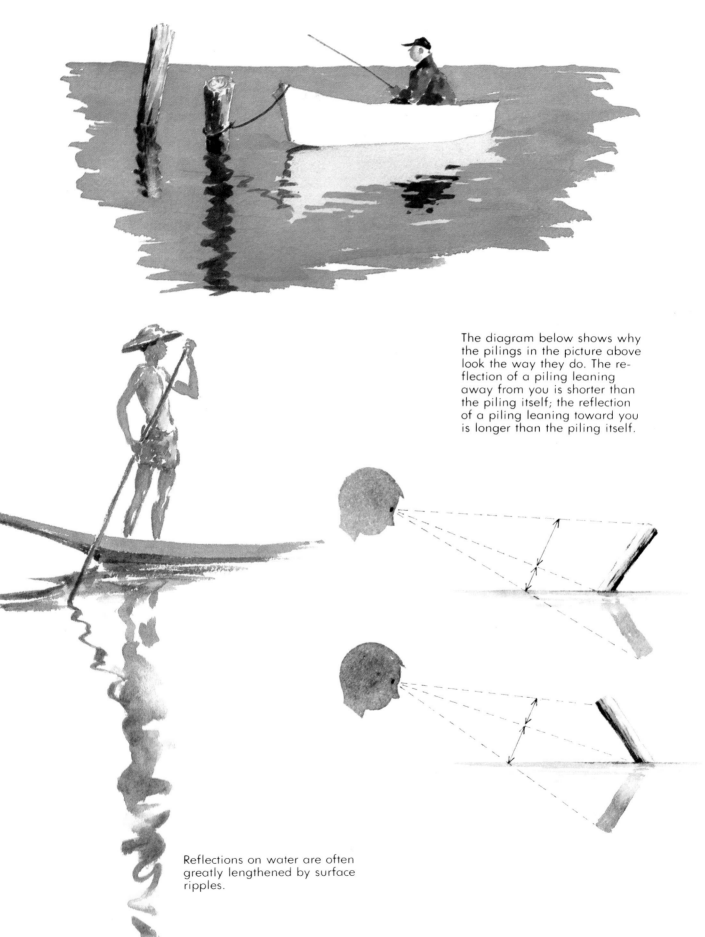

The diagram below shows why the pilings in the picture above look the way they do. The reflection of a piling leaning away from you is shorter than the piling itself; the reflection of a piling leaning toward you is longer than the piling itself.

Reflections on water are often greatly lengthened by surface ripples.

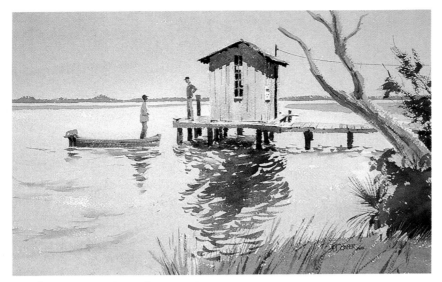

Dock at Darien, Georgia

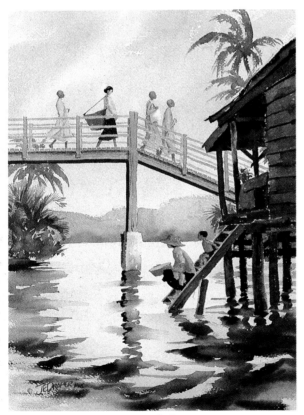

Crossing the Klong, Bangkok

Reflections are not difficult to paint and they add sparkle and life to a painting. However, they must be done right. Remember, the reflection falls in a vertical line directly beneath the object reflected. Notice, too, as in these images, that irregularities such as ripples and waves often distort, darken, and elongate a reflection.

Hong Kong Harbor

The artist sitting on the beach sees the horizon line (his eye level) crossing the standing figures at the knees.

Making the Figure the Right Size

An important thing to master when fitting a figure in the painting is the problem of scale. The figure must be the right size for its location in the picture's perspective. This is particularly challenging when placing more than one figure in the painting, since they need to be consistent with each other. If they are not the same distance from the viewer, then the closer one must be bigger and the more distant one smaller. How much bigger or smaller will determine if the figures are the right size or if they look like giants or dwarfs.

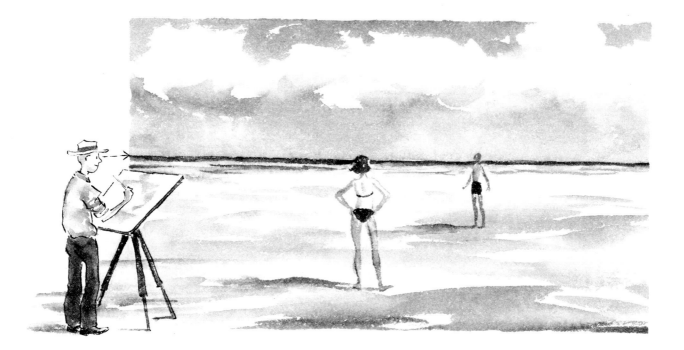

The key to this situation is the establishment of the horizon line. The horizon line is always equal to the eye level of the viewer or you, the artist, as if you were an observer in the imaginary space of the picture. Therefore any figures in this "space" standing on the same plane as you, the artist, will have their eyes at the same level which corresponds to the horizon line. Thus, the horizon line in a painting tells you just where the artist as observer of the space in the picture stood. If the horizon is high in the picture, you know the artist was on an elevation looking down on the scene. If it is low, the artist was working near ground level and perhaps looking up at his subject.

When standing, the artist sees the horizon crossing the other figures at approximately the same place, at his own eye level. Note the allowance made for the girl being shorter than the man.

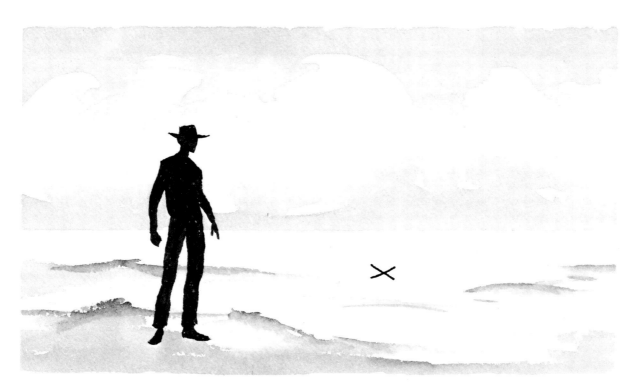

Here's the basic four-step procedure to size a second figure on the same level but at a different distance:

1. Place a mark in the painting where you want the second figure to stand.

To locate one figure in the picture, you simply need to determine if it is higher, lower, or on the same level as you, the artist as observer. If on the same level, the figure's eye will be approximately at the horizon line, which is to say at your own eye level. If above or below your level, the figure's eyes will be correspondingly above or below the horizon line.

If there is a second figure of the same height on the scene, on the same level but at a different distance from you, it's a bit more complicated to draw this figure in the same scale as the first. Here's a basic four-step procedure to follow:

1. Place a mark in the painting where you want the second figure to stand.
2. Draw a line from the first figure's feet through this mark and to the horizon line.

3. Draw a line from the first figure's head to meet the first line at the horizon.
4. The height of the second figure is measured vertically up from the place he is standing to meet the second line you drew, that is, the one from the head of the first figure.

You can use this procedure to draw any number of additional figures by using your first figure as a key.

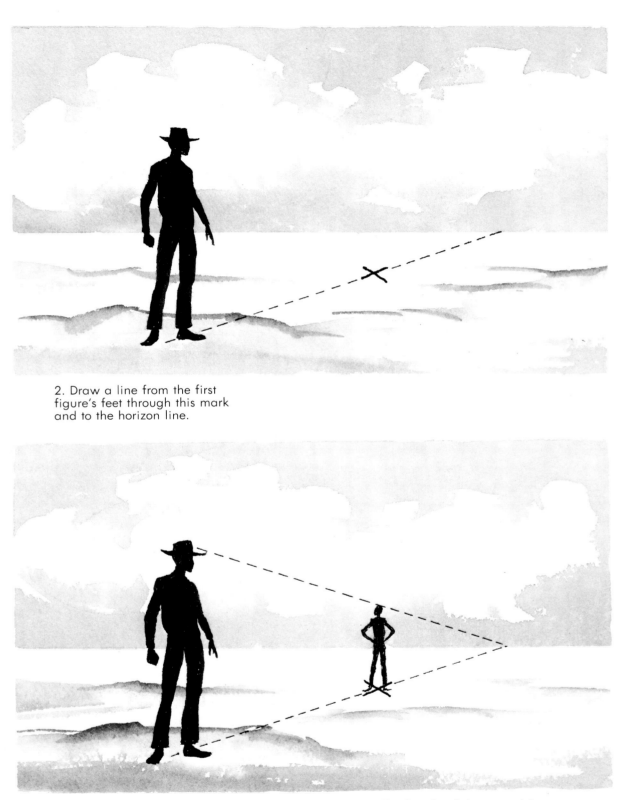

2. Draw a line from the first figure's feet through this mark and to the horizon line.

3. Draw a line from the first figure's head to meet the first line at the horizon.

4. The height of the second figure is measured from where he is standing vertically up to meet the second line you drew, that is, the one from the head of the first figure.

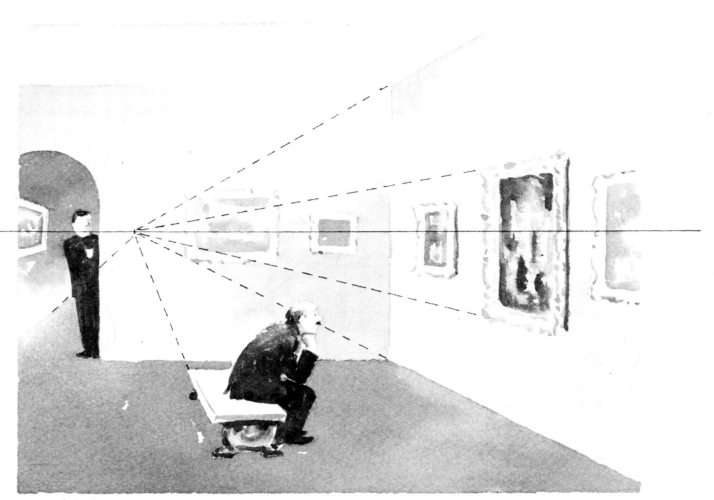

Even if the horizon is not visible in a picture, such as in this interior, it is still there at the artist's eye level. The vanishing point for the walls and frames is on this unseen line. Note that it is *not* determined by the eye level of the other figures in the painting, such as the man on the bench.

There are other ways of relating the size of one figure to another in a painting. In all these processes, the first step is to establish the horizon line. This line is always present, but not always visible. The horizon is easily seen at the seashore where sky and water meet, but elsewhere it may be hidden by trees, buildings or terrain. Nor is it visible in an interior scene. Nevertheless, it is hypothetically there and it is always at your eye level as an observer in the imaginary space of the picture.

Once you have determined where you are in relationship to the scene, whether you are looking up from below or down from above, you know where your horizon line will be. Once you have placed this horizon, you can establish the location and size of one figure and then calculate all the others based on the first. You can do this following the four-step procedure shown on pages 76-77, or you can use the measurement of part of a figure, usually head size, to place other figures.

For example, if you are above all the other figures, their eye level will be below yours and, therefore, below the horizon line. If one figure's head is two head lengths below the horizon line, all other figures on the same level will be two of their own head lengths below the horizon as well. If your eye level, that is, the horizon, is below the eye level of the figures, the same system can be used. Now the tops of the heads of all the figures will be, say, two of their own head lengths *above* the horizon. An even easier guide in this case is to note where the horizon line intersects one figure. If it crosses one figure at the waist, for example, it will cross all other figures at the waist.

All of these systems work for same-size figures standing on the same plane. If you are drawing children of the same size, you can use the system in the same manner. If you are drawing children with adults, compare the children's height in relationship to a key adult height and adjust the heights of same-size children proportionately. If you are drawing figures on unlevel terrain, they should be raised or lowered proportionately as well.

Scaling figures might sound complicated at first. It is not. Study the diagrams here carefully, then try it on your own. You'll soon discover how easy it is and how fascinating the process of playing with figure placement can be.

Another way to determine the placement and size of figures in a painting is to use a standard unit, such as head size, to measure the distance above or below the horizon line. All the figures in this picture are two of their own head lengths beneath the horizon.

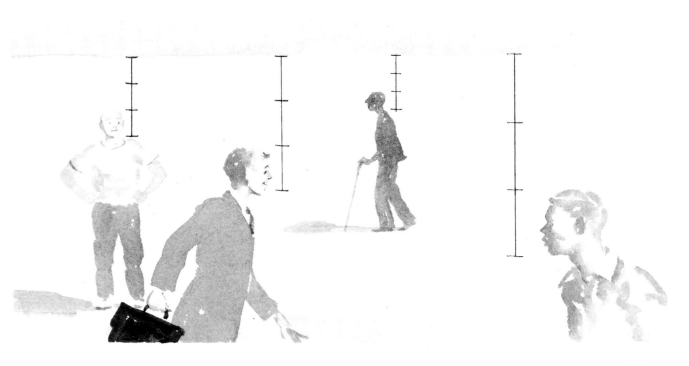

In sum, there are many things to think about when planning to place figures in a painting. The figures must look like they belong to the picture. They should be consistent in technique and lighting, they should be placed in the right position for an effective composition, and they should be the right size. Planning ahead is the best way to make sure your figure will fit and not look like an afterthought.

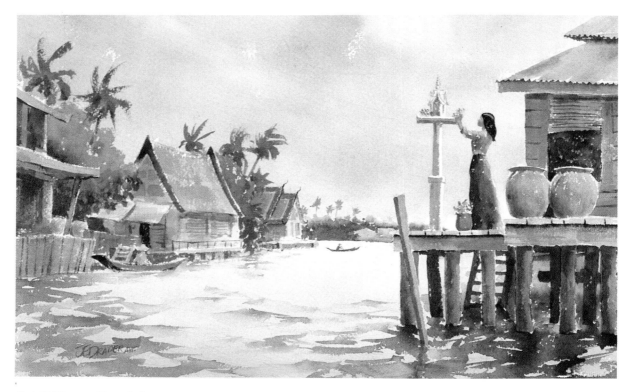

Spirit House, Bangkok

Every house in Bangkok has a small shrine or spirit house where offerings are placed to placate the spirits displaced by the construction of the dwelling.

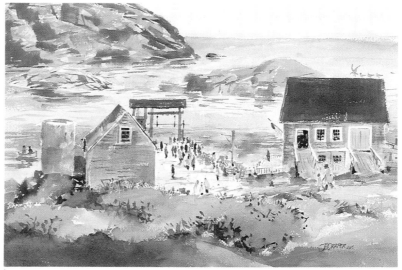

Waiting for the Mail Boat, Monhegan

The figures in this painting are barely suggested with a few strokes each. The emphasis is on the activity of the crowd gathering for the mail boat, not on any individual figure.

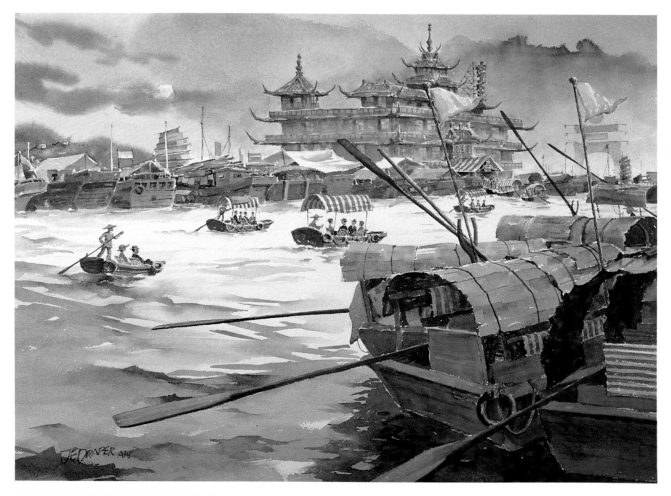

Floating Restaurant, Hong Kong

There is a large restaurant built on a barge anchored in the harbor. Customers are ferried to and from in small sampans with striped canopies. I painted them with more care and detail because they are the focal points of the composition.

Saint Jean Pied de Pour, France

Imagine how desolate and unnatural this scene would appear with no figures visible!

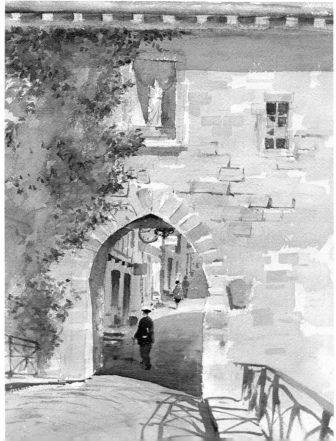

CHAPTER FIVE

People in Groups

So far we have been discussing the single figure. However, the human race is a gregarious one. People congregate to exchange goods, ideas, or conversation. More often than not, people are found in groups. We live, work, and play together, so you will no doubt want to include people in groups in your paintings.

I have already suggested that you sharpen your skills by sketching in such places as libraries, shopping malls, terminals, etc. Not only will you find plenty of opportunities there to sketch the single subject, but you'll also find them in groups. You can do gesture sketches of groups, looking for the shapes and lines that unite individuals into a single mass. You can also combine sketches of individual people into groups of two, three, or more.

The first step is to develop the ability to think in terms of a single entity rather than the sum of several separate individuals. A group is more than just a few individuals in close proximity. The group is doing something together that unites them in a special way, even if the group is just composed of people waiting for the next bus.

You will need to think of a group of figures in terms of its overall design, not of each individual, but of the group as a single unit. Group your figures with design in mind.

A group is more than several figures close together. The figures are doing something together, even if it is as simple as crossing the street together. Think of the group as a single unit and each individual as an integral part of that unit.

First, consider the overall shape of the group. Examine the silhouette—it should itself be an interesting shape. Positioning the heads on different levels, varying the distance between figures, and allowing the feet to form an irregular fringe at the bottom are ways to add interest to the group's shape. That means you should vary dimensions, avoiding boring shapes such as perfect squares or equal-sides triangles, or too many right angles.

Second, consider the pattern of lights and darks. There should be a pleasing distribution of lights and darks. There shouldn't be too much regularity in the size and spacing of the values; avoid a checkerboard pattern. Remember also to consider whether the whole group should be a darker or lighter shape than other elements in the design, so it works with the painting's composition.

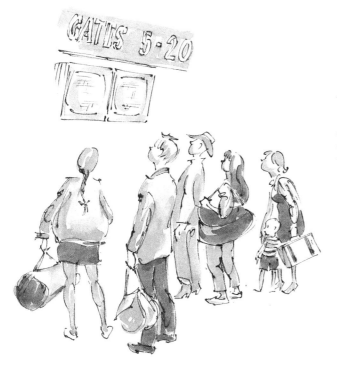

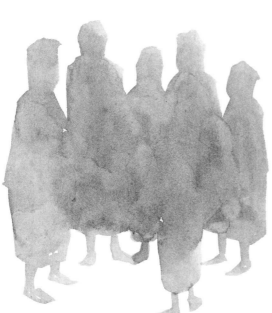

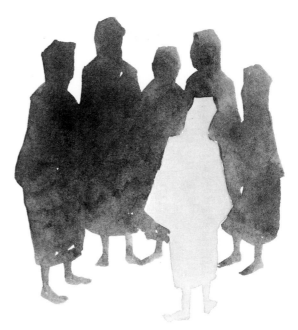

Here a group of six figures has been resolved into a single shape. Our first concern is to make the overall shape interesting. This is accomplished partly by positioning the head shapes irregularly and allowing the feet to form a "fringe" at the bottom.

After this you can turn your attention to the interior of the shape. Establish a value pattern by assigning different values to the various figures. If you continue the process by using color and adding detail, take care to maintain the value pattern.

Any group should be considered as a unit with a well designed shape and pattern of values.

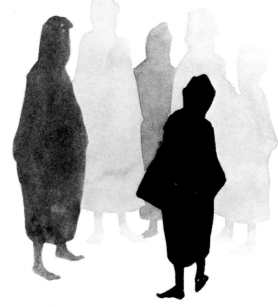

When dealing with separated figures such as these, monotony of spacing and figure interest is a design problem to avoid.

The overall silhouette shape of a group is important in these examples. Most of the detail has been omitted and color values have been kept similar.

The tiny figures in these groups are more like symbols of figures than anything else. Warm colors (reds, etc.) in the head and shoulders and cooler colors toward the ground help the figures to stand upright in your landscapes.

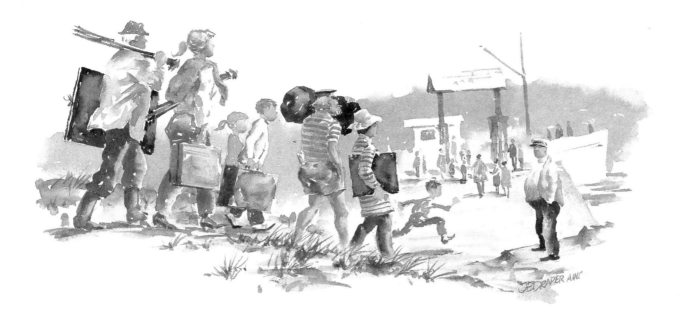

These groups were composed from figure studies in my sketchbooks.

Irregular spacing helps keep a group from looking monotonous. The figure on the far left balances the group on the right because of its dark shape.

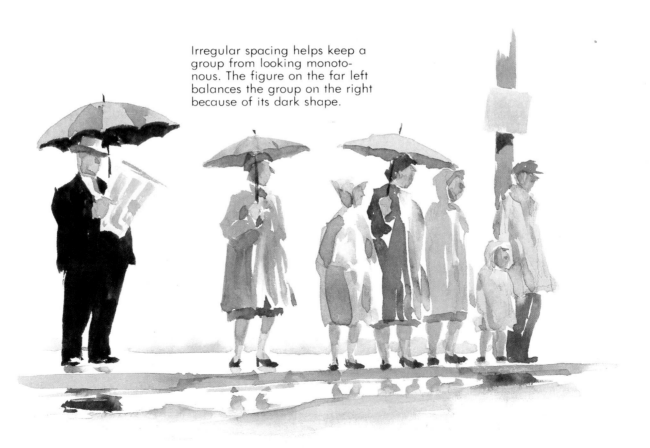

In this procession of people catching the boat from Monhegan, variety of spacing and action was important.

Whenever you put one figure together with another figure, you create a group and face certain inherent design problems. Two people are not much of a·group, but you have to start somewhere. Add a third and a fourth or more, and you create something that has to be considered as a whole and designed as one unit.

This unit can be completely joined together as a whole or it can be fragmented with parts disconnected but related. In a design sense, all of these parts, joined or disconnected, must relate to each other.

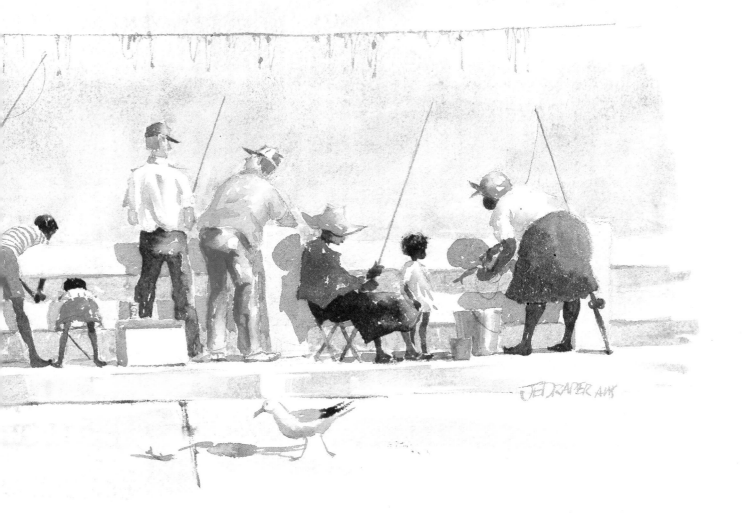

It isn't always feasible to make all the necessary design decisions while sketching on the spot, especially since people don't hold still too long. You can always rework your figure sketches into a successful group scene back at home or your studio. The sketchbook studies can also be combined to form new groups. Don't hesitate to change the shapes, values, or anything else to make the group work better for your painting. Your groups will still have the authoritative quality of having been seen and sketched firsthand.

In sum, the secret to painting groups is to think of a group as a single unit with a well-designed shape that conforms to the compositional design of your painting. If you need to differentiate figures within the shape, use an equally well-designed pattern of values with just enough detail to individualize each figure while maintaining the unity of the group.

Neighborhood Movie

People standing in line under a lighted movie house marquee struck me as being a good painting subject, but the situation didn't lend itself to sketching on the spot. As soon as I could, I made a thumbnail sketch of the scene and filed it away for future reference. I was lucky enough to find it again recently (my files being the way they are) and decided it would make a good painting.

In this case all the figures had to be created from scratch. Since my memory was only of the scene in general, the individual figures would either have to be invented or adapted from other sources, such as my sketchbooks.

The sketchbooks weren't much help, but working from memory and through much trial and error finally produced a line of people that I hope is fairly convincing.

Shown here are the thumbnails and some of the very rough figure studies that were the start. Many more than these were created and discarded, but the process yielded enough usable figures to populate the painting.

Above is the thumbnail sketch with the composition and value pattern that I felt best represented the scene. Below is one of my more detailed sketches of the line of theatergoers.

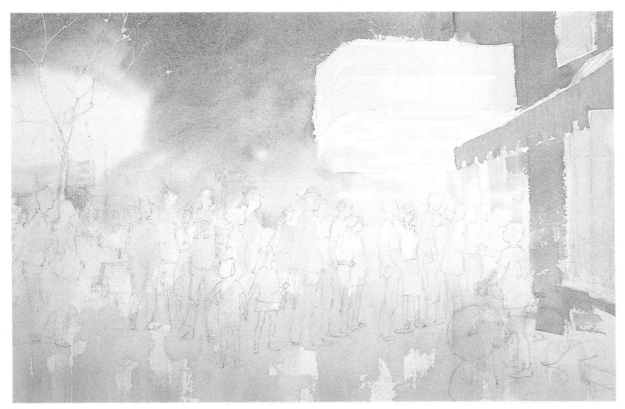

Stage One

In the rough stage, I developed an individual figure on the sketchpad until it showed some promise. At this point the figure would be positioned on the painting and developed further right on the watercolor paper. This was to avoid the loss of freshness and directness that occurs with too much redrawing and transferring.

I avoided drawing much detail, especially faces. I wanted the interest to be on the group rather than on individuals. I prefer to carry out much of the drawing with brush and color in the painting stages.

Once I had a satisfactory group in pencil, I roughly washed in the main values of the painting. This gave me the overall light and dark pattern and helped me make other value decisions as the painting progressed.

I began by positioning figures I had developed on my sketchpad in the composition. I left out detail, which I would paint in later. Then I covered the paper with a loose wash of color to establish the overall pattern of values.

Since I wanted to keep the viewer's attention on the group as a whole, rather than separate individuals, I kept detail to a minimum, especially on the faces.

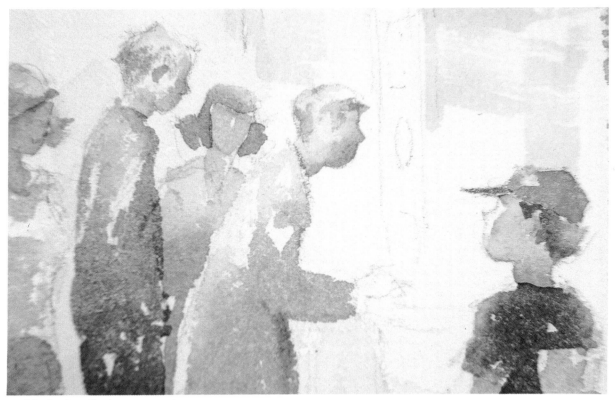

I blocked in flesh tones and clothing colors, keeping the values of the figures brighter in the glare of the marquis lights.

I decided to indicate a wet pavement in the foreground because the resulting reflections would be a good addition to the brightly lighted area. I also masked the tree and street signs so I could work loosely without worrying about details.

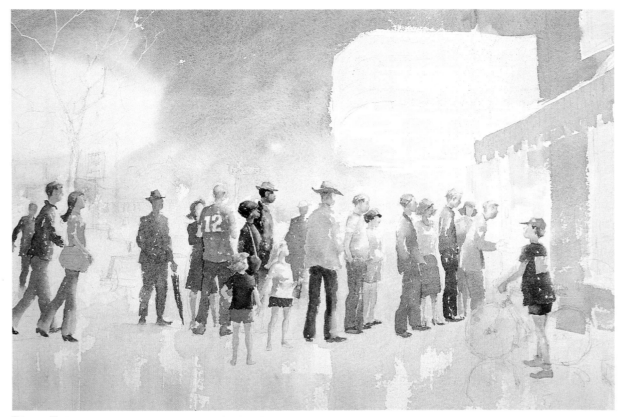

Stage Two

I then proceeded to block in flesh tones and clothing colors, knowing that there would probably be a need to adjust values as the painting progressed.

The focal point is the area directly under the marquee where the light is strongest. The colors and values in this area were deliberately kept light, because the strong glare of the overhead light plus the amount of reflected light would wash them out.

The figures beyond the periphery of the strong light were kept darker and therefore, at this stage, seemed stronger than the focal point figures. However, in the following stage, the background behind the outlying figures would become darker, reducing contrasts and leaving the brightly lighted area as the center of attraction.

At this stage, the figures outside the glare of the lights are stronger because they have greater contrast. Later, the background will darken, subdueing the contrast and shifting attention to the figures approaching the ticket window.

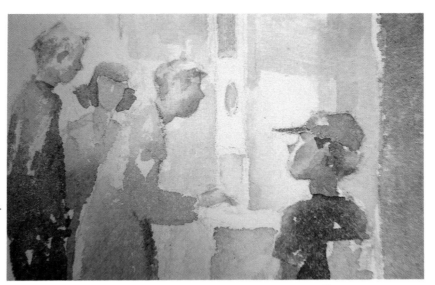

I added more detail and developed the background and reflections.

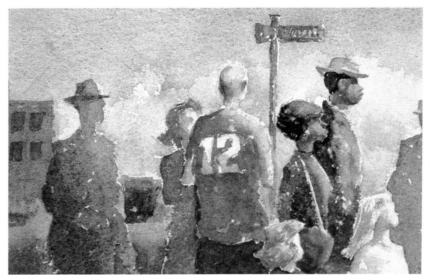

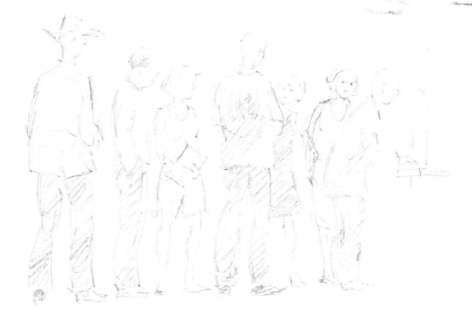

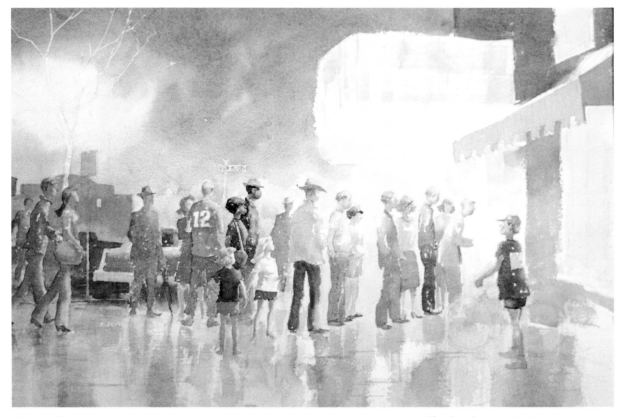

Stage Three

In this stage I added background detail and adjusted lights and darks. I decided first that the sky needed darkening, so I rewet the area and added a wash of ultramarine blue, burnt sienna, and alizarin crimson.

I put in the city street background, subject to further darkening and subduing of detail.

The foreground reflections were worked in, but would become more defined and value controlled in the next stage.

The background shapes and foreground reflections complete the composition, leaving considerable detail for the final step.

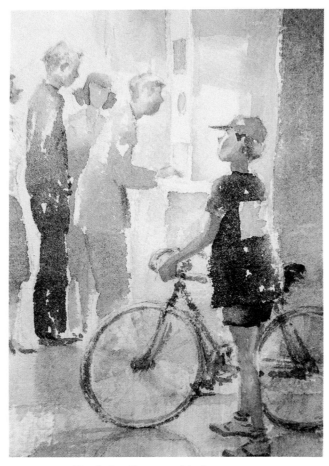

Final detail was added to com-
plete the painting. I kept an
eye on the whole painting as I
did this to avoid overworking
an area.

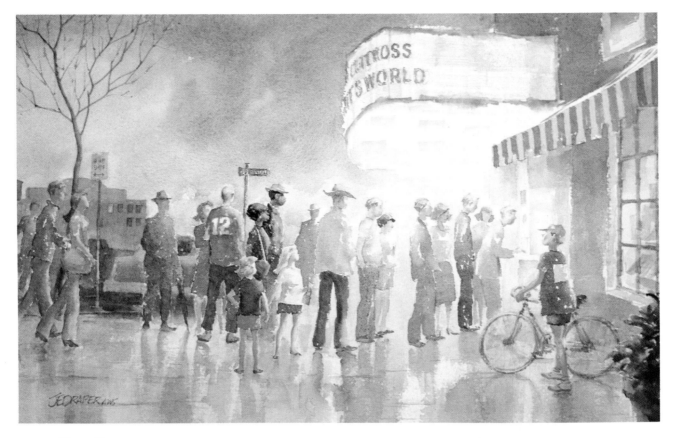

Stage Four

This is the wrap-up, and I left quite a bit of work for this stage. Most of it was detail, however, as the major decisions had already been made.

The darks and lights of the figures seemed to be working, but I still poked at them here and there, making sure certain definition stood out as I wanted it.

The foreground reflections were sharpened up and given slight accents where they joined the figures.

Other detail, ignored until now, like the store window, awning stripes, and the marquee lettering, was put in.

The boy who had been standing there leaning on a bicycle that wasn't there, now had his bike.

Although the major decisions had already been made, there was quite a bit of detailing needed to finish the painting.

DEMONSTRATION #2

Showerbreak

This is a scene observed from my office window one day back in the days when I had an office window.

A sudden shower momentarily stopped a highway construction crew. The three pipes were there and the crew moved into them to wait out the shower.

The composition was simple. This thumbnail helped me check on the value pattern.

One of the many preliminary sketches.

Stage One

The general composition is very simple. The elements were such that they almost seemed to arrange themselves as I pencilled them in on the watercolor paper. The figures were also roughly pencilled in, based on some of the studies shown here.

I chose this time to establish the rainy day mood of the painting. Using a $1.59 house painting brush, I produced the rain-streaked background and then proceeded with the background foliage and the mud and puddles of the foreground.

After drawing in the elements, I brushed in the background and foreground. Falling rain was created with a house painting brush.

Details of the figures. The faces
were almost in their complete
development at this point. I
wanted to keep them simple.

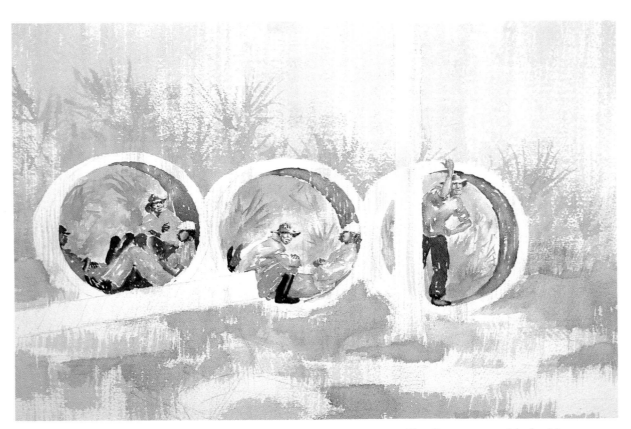

Stage Two

Now I turned my attention to the figures. The overall treatment would be kept very simple, as I felt too much definition here would affect the mood of the painting. The clothing colors were blocked in and the faces carefully painted with as few strokes as possible. The faces were practically finished at this early stage. I didn't want them to appear worked on, since this would be inconsistent with the rainy day appearance of the painting.

I also painted in the background around the figures and painted the inside surface of the pipes.

The figures were blocked in and the background painted in around them. I didn't want too much detail, which was obscured by rain in the original scene.

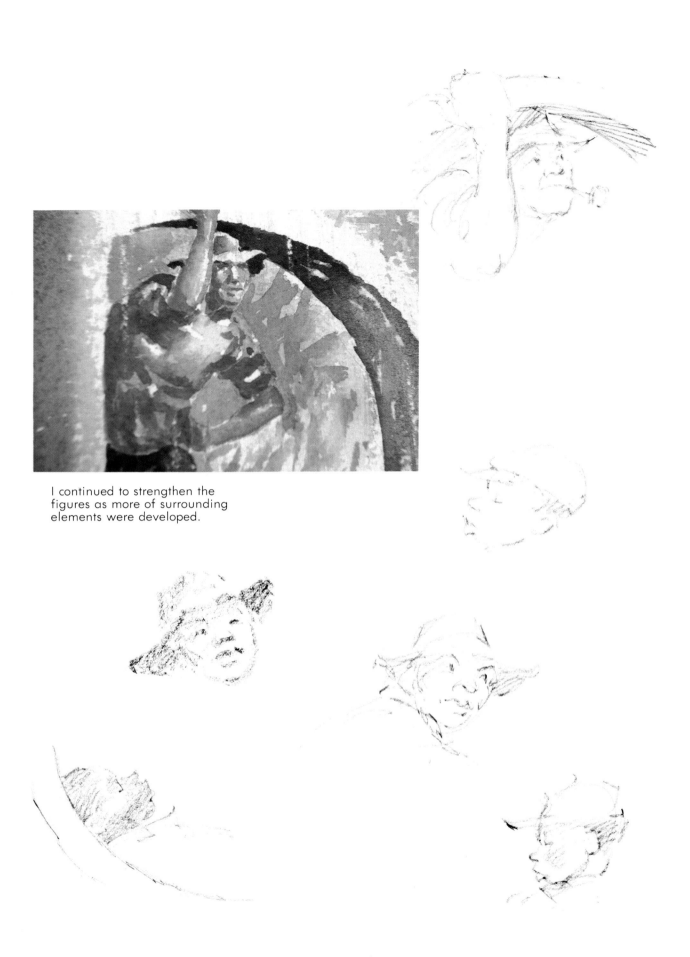

I continued to strengthen the
figures as more of surrounding
elements were developed.

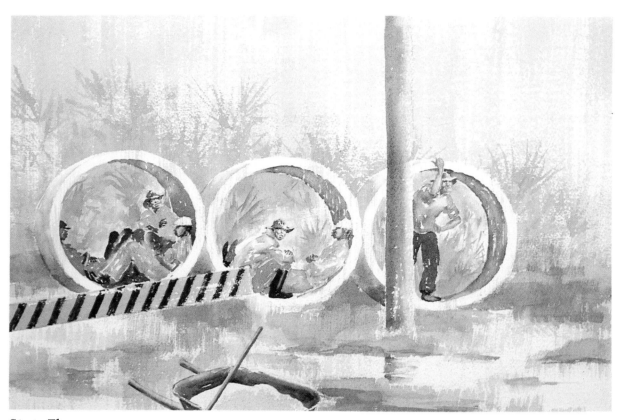

Stage Three

The other compositional elements seem to have been ignored until now. The pole, the road barrier, and the wheelbarrow were painted in, enabling us to see the pattern these elements provide.

I also completed the pipes by painting their outside surface. Then I added the reflection of the pole and a few darks to the foreground mud. These darks would be strengthened in the final stage.

In this stage the pole, barrier, and wheelbarrow were completed. Painting is an adjustment process. As the painting evolved, areas such as the pipes needed to be detailed.

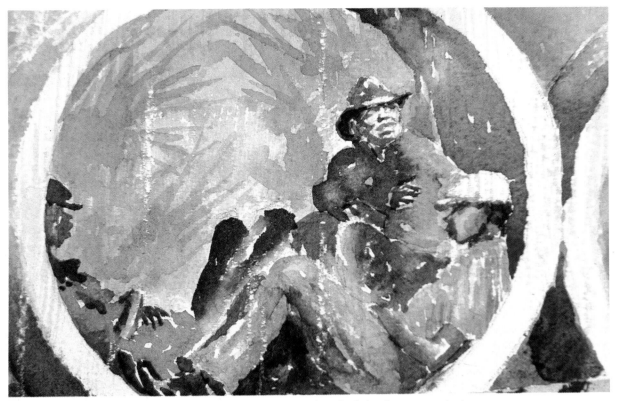

A detail of the figures with the final touches.

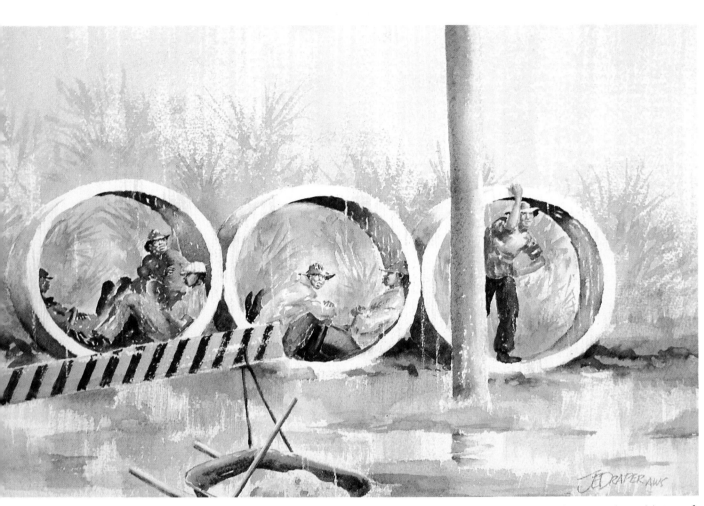

Stage Four

As usual the final stage is the completion of detail and the final adjustment of lights and darks.

The figures needed some strengthening by means of added darks. Dark was also added to the inside wall of the pipes at the top.

Other darks were placed on the ground, under and around the pipes. A little more work was done on the foliage background, tightening in around the figures.

Finally, I used a knife to scrape in a few additional rain streaks and called it finished.

The final step is the addition of detail and modification of the values. I used a knife to scrape in a few last streaks of rain.

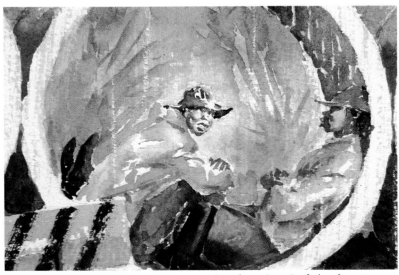

Another detail of the figures. Some values were darkened to give them more definition.

DEMONSTRATION #3
Grenada Waterfront

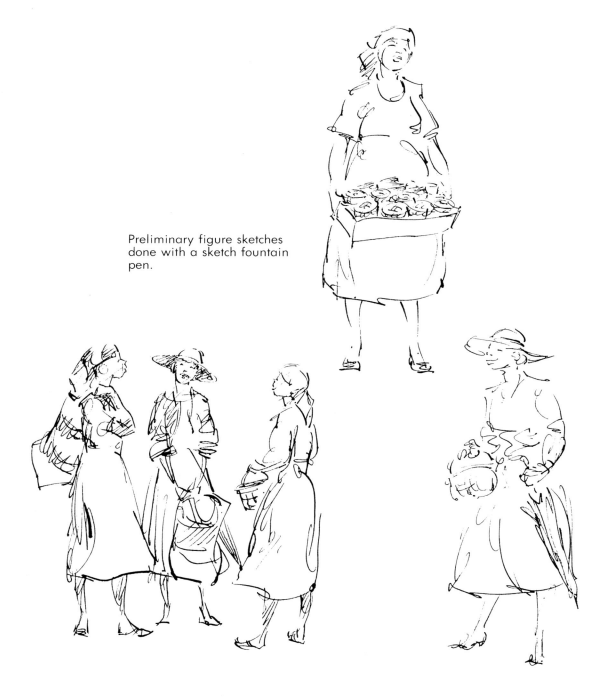

Preliminary figure sketches done with a sketch fountain pen.

After considerable experimentation, I arrived at the right level for the horizon line.

Once the horizon line was established, I could complete the drawing and begin laying washes to establish colors and values.

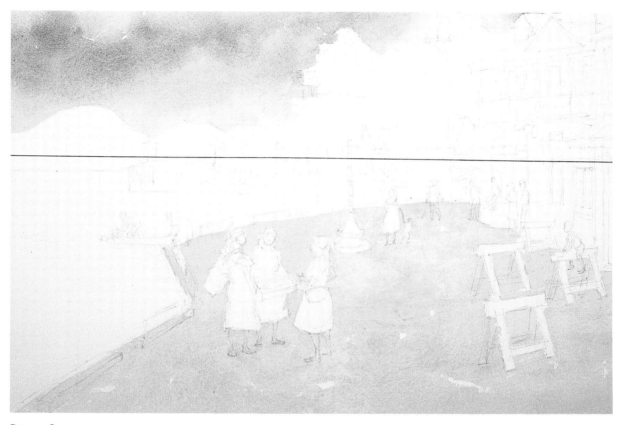

Stage One

This section of Grenada's waterfront, following a shower, seemed to lend itself to becoming a "people painting."

The subject gives us a chance to put our lesson on perspective into practice. Without using a knowledge of perspective the foreground figures could have been either too small or too big in relation to the background figures.

The first step, as explained earlier, was to establish the horizon line. This line is always the eye level of the observer, which in the beginning is the artist. By experimenting, I found that lowering my eye level to the eye level of the foreground people made them so much taller than the horizon, that they blocked out much of the background interest.

Experimenting further I raised my eye level (and the horizon) until the foreground figures and the background figures both fit comfortably into the composition. Following the method explained in Chapter Four, I used the woman with the umbrella in the background as my key figure to determine the size of the woman on the left in the foreground group. It was simple, after this, to relate other figures to these by eye.

I have temporarily placed my horizon line on the painting, so you can check me on this.

The figures in this demonstration are small and more typical of figures you would usually be using as part of a landscape painting. The smaller the figures, the less detail, but it is still important that they be properly proportioned and show correct action.

These figures were created for this painting from memory, sketches, and imagination. Some of the preliminary studies are shown here.

When I sketched in the figures,
I included only enough lines to
establish their basic contours.

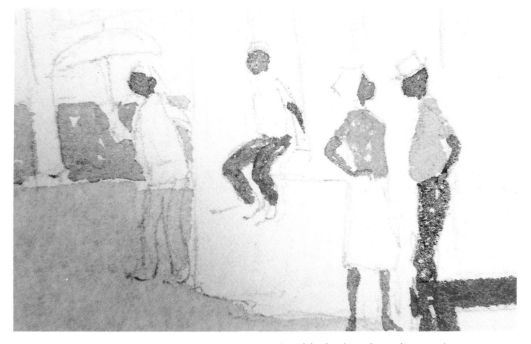

As I blocked in the colors and
values on the figures, I let my
brush complete the drawing.
Letting the white of the paper
peek through added some
sparkle to the painting.

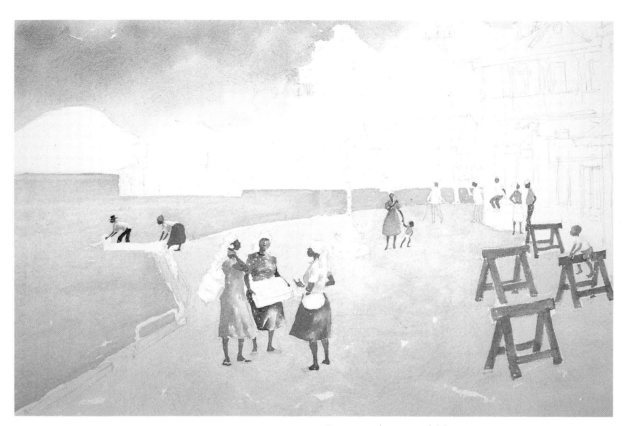

Stage Two

I decided this was the time
to spot in some of the
stronger and brighter colors
because of the influence they
would have on the rest of the
painting. This reasoning also
led me to change the color of
the road barrier horses from
the red I originally intended
to blue. All that red in the
foreground would just seem
to get the painting off to a
wrong start.

Placing the other colors
was a matter of getting a
good distribution. I moved
around among the figures,
placing a red here and anoth-
er color there where they
seemed to work best. I didn't
work on any figure detail at
this time. That would be
done in the final stage.

The light blue of the water
was also put in.

Because they would be a prom-
inent part of the painting's
composition, I painted in some
of the stronger and brighter
colors early in the painting's
development.

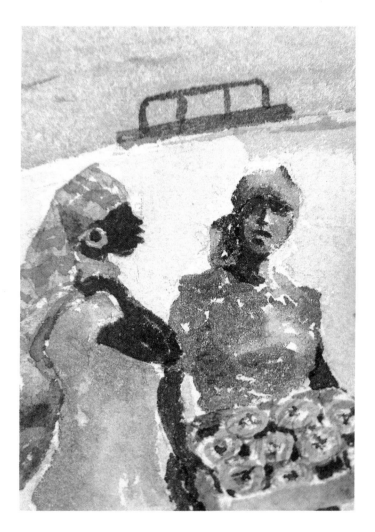

Here are two close-ups of some of the figures. Although there is very little detail, what is shown was carefully chosen to establish the figures' activity or identity. Even the smallest background figure must look natural and alive.

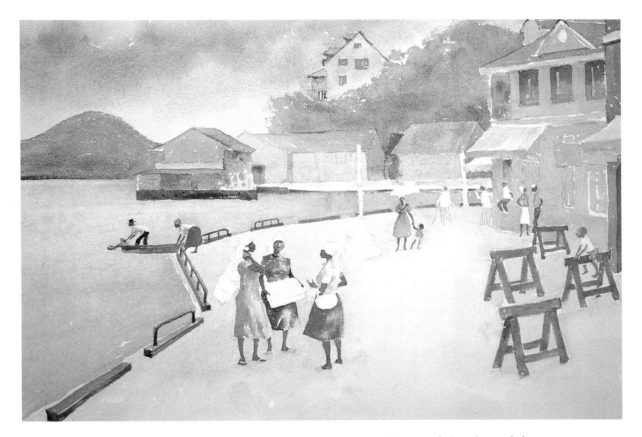

Stage Three

It was now time to work on the background. The colors of the buildings, the distant shore, and the tree-covered hill are done mostly in muted colors that would not compete with the colors used in our figures.

For the detail of the buildings and the composition of the scene generally, I referred to a slide taken during a visit several years before. The buildings across the water have been kept fairly accurate but I have taken drastic liberties with the buildings in the right foreground. I think I kept the general overall feeling, but I have moved and changed windows, doors, and rooflines to suit myself and the painting. The painting is the important thing, not the accuracy of detail.

Using a slide taken while on a visit to the island as a reference, I painted in the background. I took liberties with the buildings on the right, changing them to make a better painting.

Stage Four

The important basic parts of the painting were behind me but, in this final stage, much work remained. It was mostly detail but these were the important touches that determine the final flavor and often the success of the painting.

I started with the background buildings, adding windows and sharpening rooflines, and worked forward.

Moving to the buildings in the foreground, I was faced with a lot of work. The windows, doors, and the porch with its ironwork railing had to be finished. As an afterthought, I even added a wash of green to the entire building to separate it further from the other background colors in the painting.

The black and white traffic tower was another detail to work on. Then came the waves and ripples, which emphasized the very light color of the water.

The reflections on the street are an important part of the painting because of the interest they add to the foreground. However, since I don't like to do reflections before whatever is being reflected has been painted, I turned back to completing the figures.

I added the head scarves and the bags and boxes the foreground figures are carrying. The flat box contains small baskets of assorted spices to be sold to cruise tourists as they come ashore. Grenada is "The Spice Island."

As the smaller background figures were completed and touched up, I was ready to do the reflections.

Reflections are always on a vertical line directly below the object being reflected. Some artists confuse reflections and shadows, but reflections never stray off to the side as a shadow can.

Their purpose here is to make the street look wet. Hard edges helped create this look, but some soft edges were mixed in because of the rough and uneven texture of the street surface.

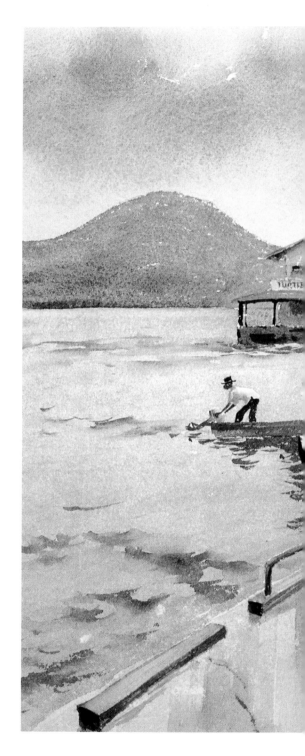

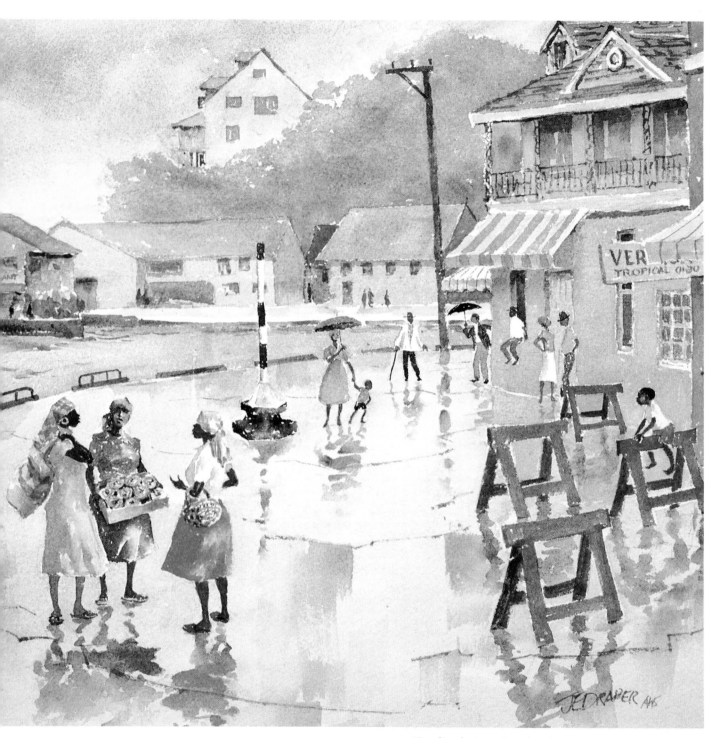

The final stage involved many small details and finishing touches, but it is often these details that make the painting a success. The reflections were simple, but they made a tremendous difference. Notice that reflections are always on a vertical line directly below the object reflected.

DEMONSTRATION #4
Deck Cargo

I developed the individual figures separately, then positioned them in the composition.

This is the drawing phase. I assembled the composition from an assortment of figure studies developed individually.

Stage One

This is based on a scene I witnessed in the West Indies. I have taken a few liberties with its final representation, but I hope it retains the basic flavor of what I saw. (Goats do have a basic flavor.) In the West Indies, the goats and the sheep are hard to tell apart. I learned from the natives that if the animals' tails stood up they were goats, if down they were sheep. I couldn't tell which these were with any certainty, so I have kept the tails in a noncommital position, but I will refer to them as goats as I talk about the painting.

This first stage is the drawing stage. I found myself dealing with much compli-cated detail. I developed the drawings of the figures and the goats separately and placed them in the painting when I was satisfied with them individually.

I planned to handle the goats on the boat as a monochromatic mass with minimum detail, so I indicated their forms with a pale warm gray with just a suggestion of shading to separate them individually.

I like to establish the feeling of the setting early, so I included the sky, the background land mass, and some foreground tones in this stage also.

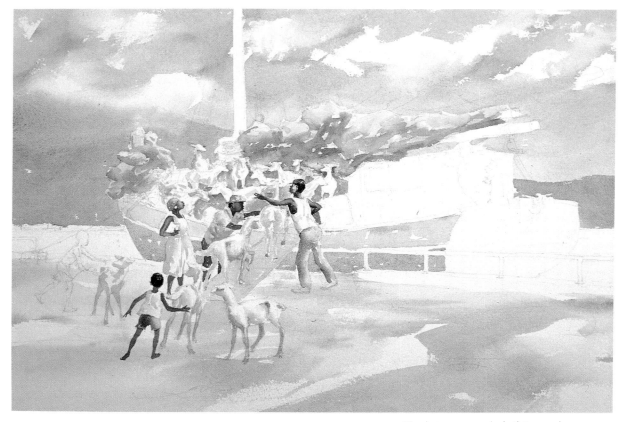

Flesh tones and clothing colors are blocked in.

Stage Two

The next step was to block in most of the flesh tones and clothing colors. This established the figures in the composition so I could work around them with other colors and values. I made sure each figure could be seen sufficiently against the very busy background.

Adding washes of color to the boat's hull provided an additional background tone to support the figures. I also worked some darks above and behind the goats on the deck to make them stand out.

116

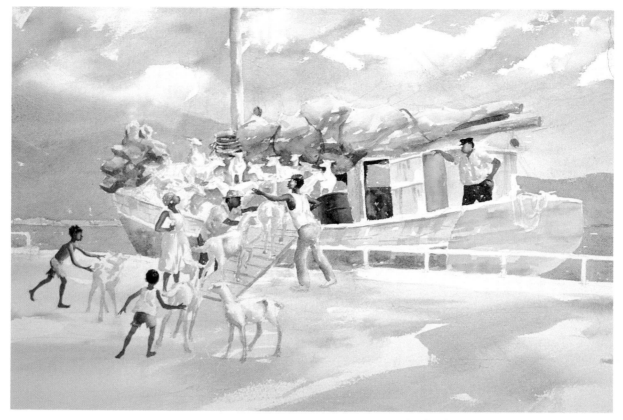

The background is blocked in and certain values adjusted.

Stage Three

In this stage, I built up the background darks so that the goats and the figures would be the focal points. The lower part of the furled sail was darkened to contrast with the light-colored goats.

The boat's cabin and the captain were also roughed in at this point, as well as the boy's figure at the left.

I was now at the stage of dealing with final detail and adjusting values and colors here and there.

The final detailing is done. At
this point, I adjust the lights
and darks to clarify and define
the painting.

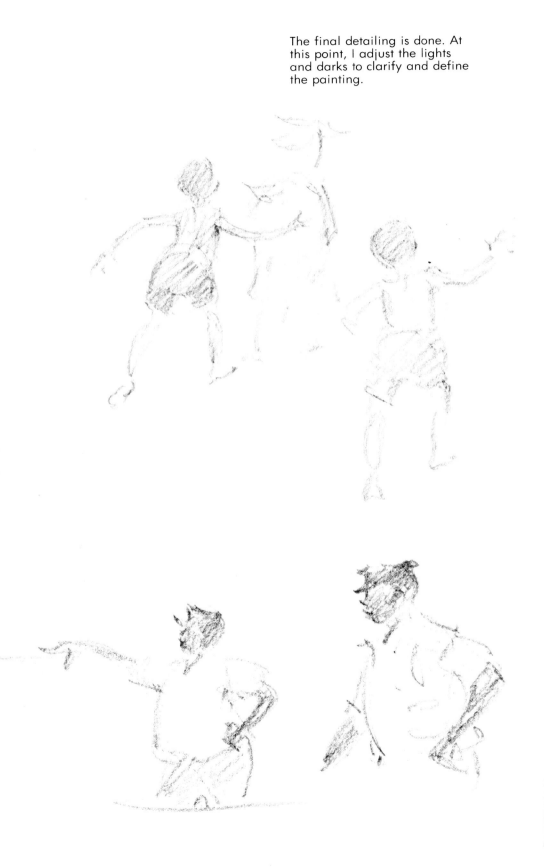

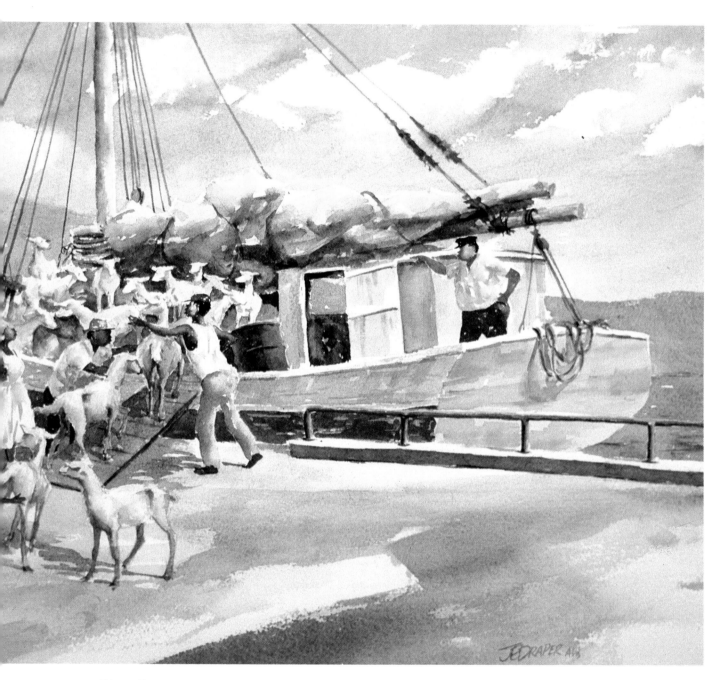

Stage Four
At this point everything was final. I started at the top and completed the rigging.

I worked on the foreground goats. They had to stand out more, so I darkened the shadows. Shadows on the ground were also added. These gave considerable strength to the foreground detail.

Going back over the boat, I added stronger color to the hull and worked on other details, including the yellow stripe on the hull.

A few darker strokes in the foreground, and it was time to leave it alone.

DEMONSTRATION #5
Watercolor Workshop

The figure sketches were developed to a fairly detailed degree before being transferred to the watercolor paper.

This scene should be familiar to anyone who has attended a watercolor workshop. As usual, I developed the figures in my sketchpad, then copied the completed figures to my water-color paper.

Stage One

This scene is a watercolor workshop on the coast of Maine. Except for the setting, with which liberties have been taken, the scene is a concoction of workshops in general. The participants are busy with their versions of the location subject. The instructor, having finished his demo, is circulating offering criticism and suggestions.

As always, this first stage is the drawing stage. First the composition was developed and the number and disposition of the figures decided. Next, on a layout pad, the figures were worked on individually. When they passed inspection, they were redrawn on the watercolor paper.

The sky and water background were also done at this time. I wanted to depict a sunny, pleasant, Maine coast type of day.

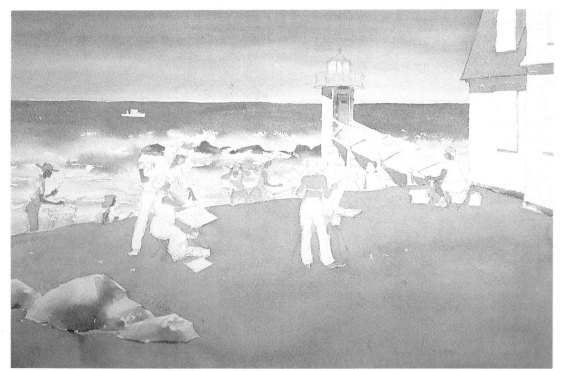

The foreground and flesh tones are added. Figures on the far side of the slope were covered with an overall tone of gray because they are lit from behind.

I try to maintain some of the loose gesture style for the initial drawing and painting stages.

Stage Two

The figures on the far side of the slope are somewhat backlighted by the great amount of light coming off the water. For this reason, I painted each of them with an overall tone of medium gray. This was to insure that they would start off sufficiently strong in value as the painting progressed.

Next, I added the flesh tones to all the figures. This was just a preliminary light tone to be pointed up later with added darks.

Turning my attention to the grass, I washed in the entire ground with new gamboge, and when this was dry, I followed with a wash of green. The yellow underpainting imparts a sunny look to the green.

There were some rocks out of the picture to the left. I moved them in to add interest and strength to the foreground.

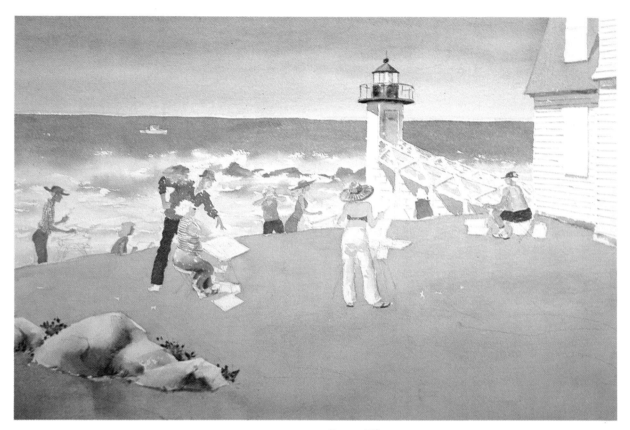

The clothing colors are added, creating much of the mood of the scene.

Stage Three
The clothing colors of the workshop are an important part of this particular painting. I wanted to get variety and a good distribution. I used white on the girl standing in the middle to tie in with the whites of the building. The rest of the figures were given an assortment of what seemed to be the natural colors for this situation.

Before moving on, I did some more work on the building, adding the clapboards and completing the shadows. I also added some dark foliage around the foreground rocks.

A detail of the final stage. The brush work was kept loose and detail was minimized.

In this last stage I painted in the easels and equipment typical of a watercolor workshop.

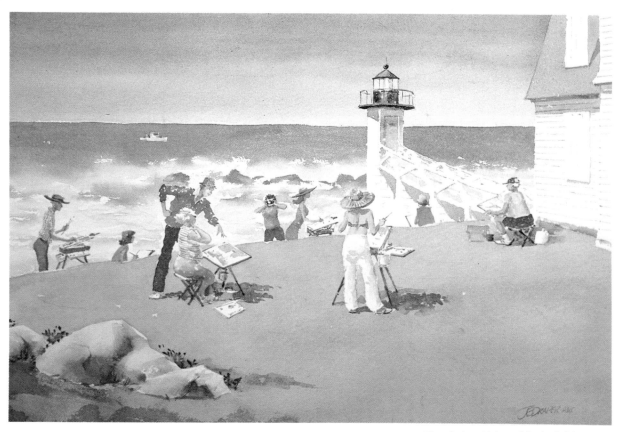

Final detail is added. Adding shadows under the figures creates the impression of sunlight.

Stage Four

The final stage is almost always a matter of completing detail and adjusting colors and values.

The detail of all the easels and other painters' paraphernalia had been put off until now. There were no problems with this. The drawing was already there and I just provided each painter with whatever was needed.

At this point, I also added some darker shadows to the flesh tones of each figure. This strengthens them and gives a suggestion of modeling.

Adding shadows on the ground under the figures helped establish the sunniness of the day and seemed to anchor the figures in place.

The windows of the building were boarded up as shown here. I toyed with the idea of removing the boarding and putting the windows in, but I decided this would just add unnecessary detail to an already busy painting.

GALLERY

Here is a collection of my paintings that will show you how the figure works in completed compositions. In some, the figure is a prominent feature; in others, it is merely incidental. Either way, the figure adds an all-important spark of life that gives a painting vitality and interest. No matter how small or insignificant a figure might seem, it contributes a sense of reality to the scene.

Drawing is the key to the successful creation of believable figures for your paintings. I hope these paintings will inspire you to draw constantly. Get in the habit of drawing the figure, from life and from memory, whenever you can. Not only will it enable you to populate your paintings, you will discover that drawing people is fun!

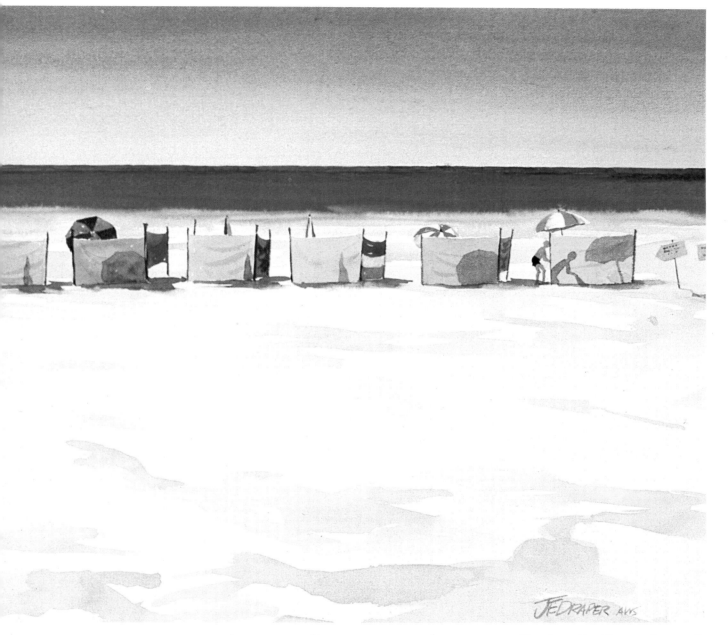

Here we see a row of windscreens that beach-goers in Portugal rent for their day on the beach. I was attracted to the strong pattern the colorful screens formed along the beach, which I thought would create a very modern design.

Beach on the Algarve, Portugal

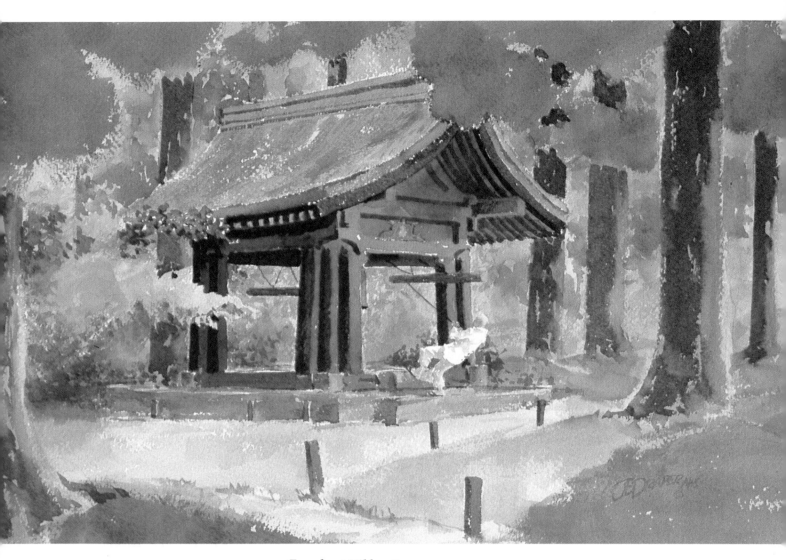

Temple at Nikko, Japan

Nikko is a large national park in Japan, and a favorite spot for tourists. It contains a number of ornate temples and shrines, including this temple housing a large gong. A monk periodically rings the gong by hitting it with a swinging beam.

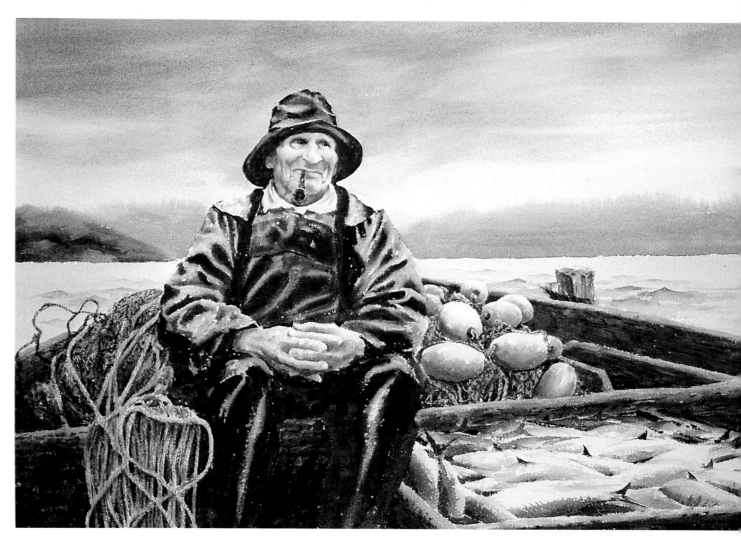

The Old Timer
Collection of Mr. & Mrs. Hansen

This painting was commissioned by neighbors of mine who wanted a portrait of their grandfather, a Norwegian fisherman. A commercial fisherman, he went fishing every day until he was in his 90's.

Woman Crabbing

Crabbing is an often-seen activity where I live in northern Florida. When word gets around that the crabs are in, the people come down to the shoreline in droves. They use a pole with a baited string, which they drag in slowly when they have a crab nibbling on the bait. Then, plop!—the crab goes into a basket to be steamed and eaten right out of the cracked shell.

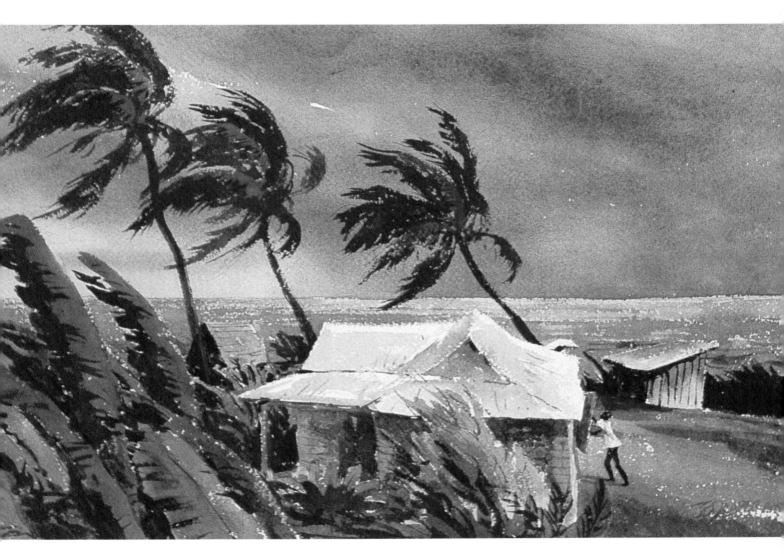

Storm Brewing, Jamaica

This scene was painted from memory. While crossing the island on a bus, I glimpsed this man urgently shuttering his house. The dark, threatening sky warned of the approach of a storm of near-hurricane strength.

Folly Point Light, Jamaica

Collection of Mr. Raymond G. Poole

In this painting, I've tried to capture the lifestyle of the lighthouse keeper and his family. The lighthouse was their home, and their laundry was hung out to dry in the yard. The keeper had some cattle that roamed around the base of the tower, and the tower sported bright red stripes, like a barber's pole. I left them out so the emphasis would remain on the family and how they lived.

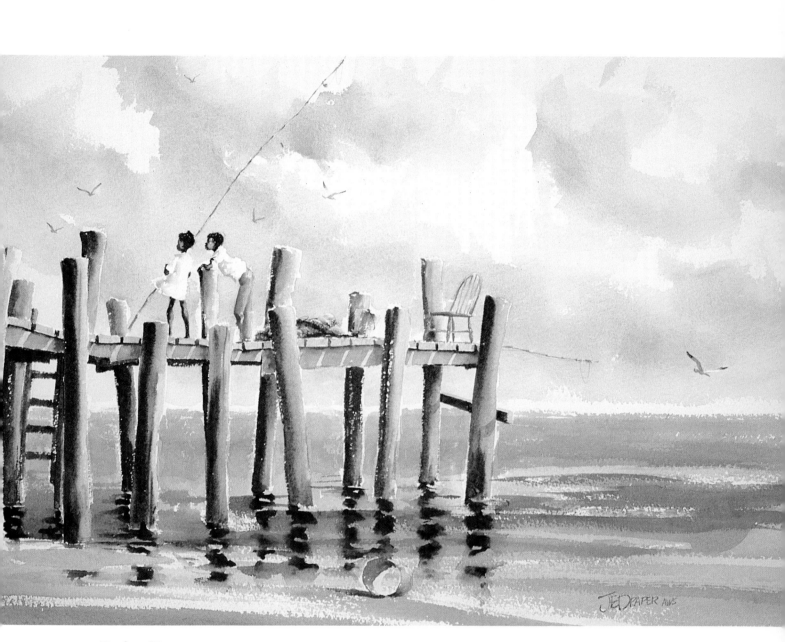

Dock at Mayport

It's a common sight to see kids with their cane poles fishing from the docks in northern Florida. It's legal to fish anywhere in your own county without a license, with only the pole and line. No reels allowed. The dock and the chair on it were painted as I saw them, but the kids were developed from other sketches and from memory.

Beach at Nevis, British West Indies

I was attracted to this scene by its brilliant colors while I was conducting a workshop on location on the island. The intense heat of the midday sun was almost unbearable.

Monhegan Fish House

Collection of Mr. & Mrs. William W. Draper

The man in the doorway is one of the commercial fishermen who lives and works on Monhegan Island, off the coast of Maine. I was fascinated by all the paraphernalia around the boat house. The poles with the flags are used as markers so fishermen can return to retrieve their nets filled with the day's catch.

Other Art Books from North Light

Watercolor

Basic Watercolor Painting, by Judith Campbell-Reed $15.95 (paper)
Capturing Mood in Watercolor, by Phil Austin, $26.95 (cloth)
Getting Started in Watercolor, by John Blockley $19.95 (paper)
Make Your Watercolors Sing, by LaVere Hutchings $22.95 (cloth)
Painting Flowers with Watercolor, by Ethel Todd George $17.95 (paper)
Painting in Watercolors, edited by Yvonne Deutsch $18.95 (cloth)
Painting Nature's Details in Watercolor, by Cathy Johnson $24.95 (cloth)
Watercolor Energies, by Frank Webb $17.95 (paper)
Watercolor Fast & Loose, by Ron Ranson $21.95 (cloth)
Watercolor for All Seasons, by Elaine and Murray Wentworth $21.95 (cloth)
Watercolor Interpretations, by John Blockley $19.95 (paper)
Watercolor Options, by Ray Loos $22.50 (cloth)
Watercolor Painter's Solution Book, by Angela Gair $24.95 (cloth)
Watercolor Painting on Location, by El Meyer $19.95 (cloth)
Watercolor—The Creative Experience, by Barbara Nechis $16.95 (paper)
Watercolor Tricks & Techniques, by Cathy Johnson $24.95 (cloth)
Watercolor Workbook, by Bud Biggs & Lois Marshall $18.95 (paper)
Watercolor: You Can Do It!, by Tony Couch $25.95 (cloth)
Wet Watercolor, by Wilfred Ball $24.95 (cloth)

Watercolor Videos

Watercolor Fast & Loose, with Ron Ranson $29.95 (VHS or Beta)
Watercolor Pure & Simple, with Ron Ranson $29.95 (VHS or Beta)

Mixed Media

A Basic Course in Design, by Ray Prohaska $12.95 (paper)
Calligraphy Workbooks (4 in series) $7.95 each
Catching Light in Your Paintings, by Charles Sovek $16.95 (paper)
Colored Pencil Drawing Techniques, by Iain Hutton-Jamieson $23.95 (cloth)
Drawing & Painting with Ink, by Fritz Henning $24.95 (cloth)
Drawing & Painting Animals, by Fritz Henning $14.95 (paper)
Drawing & Painting Buildings, by Reggie Stanton $19.95 (cloth)
Drawing By Sea & River, by John Croney $14.95 (cloth)
Drawing for Pleasure, edited by Peter D. Johnson $15.95 (paper)
Drawing Workbooks (4 in series) $8.95 each

Exploring Color, by Nita Leland $26.95 (cloth)
The Figure, edited by Walt Reed $15.95 (paper)
Flower Painting, by Jenny Rodwell $19.95 (cloth)
Keys to Drawing, by Bert Dodson $21.95 (cloth)
Landscape Painting, by Patricia Monahan $19.95 (cloth)
The North Light Handbook of Artist's Materials, by Ian Hebblewhite $24.95 (cloth)
The North Light Illustrated Book of Painting Techniques, by Elizabeth Tate $27.95 (cloth)
Painting & Drawing Boats, by Moira Huntley $16.95 (paper)
Painting Birds & Animals, by Patricia Monahan $21.95 (cloth)
Painting Nature, by Franklin Jones $17.95 (paper)
Painting Portraits, by Jenny Rodwell $21.95 (cloth)
Painting Seascapes in Sharp Focus, by Lin Seslar $24.95 (cloth)
Painting with Acrylics, by Jenny Rodwell $19.95 (cloth)
Painting with Pastels, edited by Peter D. Johnson $16.95 (paper)
Pastel Painting Techniques, by Guy Roddon $24.95 (cloth)
The Pencil, by Paul Calle $16.95 (paper)
Perspective in Art, by Michael Woods $11.95 (paper)
Photographing Your Artwork, by Russell Hart $15.95 (paper)
Putting People in Your Paintings, by J. Everett Draper $22.50 (cloth)
The Techniques of Wood Sculpture, by David Orchard $14.95 (cloth)
Tonal Values: How to See Them, How to Paint Them, by Angela Gair $24.95 (cloth)
You Can Learn Lettering & Calligraphy, by Gail & Christopher Lawther $15.95 (cloth)

Oil/Art Appreciation

Encyclopaedia of Oil Painting, by Frederick Palmer $22.50 (cloth)
Oil Painting: A Direct Approach, by Joyce Pike $26.95 (cloth)
Painting in Oils, edited by Michael Bowers $18.95 (cloth)
Painting with Oils, by Patricia Monahan $19.95 (cloth)

To order directly from the publisher, include $2.50 postage and handling for one book, 50¢ for each additional book. Allow 30 days for delivery.

North Light Books
1507 Dana Avenue, Cincinnati, Ohio 45207
Credit card orders
Call TOLL-FREE
1-800-543-4644 (Outside Ohio)
1-800-551-0884 (Ohio only)
Prices subject to change without notice.